This exhibition explores Jewish life through artifacts and texts. The artifacts come from the collections of the partners in the Center for Jewish History. The texts reflect the viewpoints of many individuals.

All of the collections in the Center for Jewish History are survivors, repositories of historical information and powerful markers of shared memory. In its conception, this exhibition parallels the coming together of five institutions, each focusing on a distinct aspect of Jewish history. Here these divisions vanish, in recognition of shared experience and unity.

MAJOR INTERSECTIONS

The physical design of the exhibition reflects three overarching themes of Jewish experience: Exodus and Transition, Rootedness and Community, Transmission and Regeneration.

We are guided by a variety of commentators: historians, authors, scholars, politicians, eyewitnesses and the exhibition designer. As Jews have done throughout the millennia, they question, challenge, interpret and expand our discussion.

ISBN 0 - 945447 - 11 - 6

TABLE OF CONTENTS

PREFACE . PAGE 2
Sylvia A. Herskowitz

ACKNOWLEDGEMENTS . PAGE 3

MAJOR INTERSECTIONS: AN INTRODUCTION . . PAGE 7
Norman Lamm

MAJOR INTERSECTIONS: AN OVERVIEW PAGE 13
Lawrence H. Schiffman

DESIGNER'S STATEMENT . PAGE 28
Constantin Boym

I. EXODUS AND TRANSITION PAGE 30
Gabriel M. Goldstein

 Catalogue entries and selected commentaries PAGE 32

II. ROOTEDNESS AND COMMUNITY PAGE 42
Hasia R. Diner

 Catalogue entries and selected commentaries PAGE 45

III. TRANSMISSION AND REGENERATION PAGE 58
Michael F. Stanislawski

 Catalogue entries and selected commentaries PAGE 61

PREFACE
SYLVIA A. HERSKOWITZ

When *Major Intersections* was first conceived, we wanted the exhibition to represent the underlying concept of the Center for Jewish History — the coming together, at one address, of five separate Jewish institutions and their history-based collections. As a Museum dedicated to the interpretation of Jewish history, our exhibitions have offered audiences the opportunity to perceive the spirit and essence of a culture, not merely as a display of precious artifacts, but as the distillation of values, lifestyles and folkways that might be called the DNA of a particular community.

Now, instead of a single community under scrutiny, our focus was global: to present Jewish history in its length and breadth, viewed as it were, from a satellite, upheavals, tidal waves, seismisms, all refracted through the prism of material culture — the extraordinary hoard of collective treasures housed for the first time within Center walls.

As the exhibition took shape under the leadership of Curator Gabriel Goldstein, Scholars Committee Chair Professor Lawrence Schiffman and a roster of distinguished historians, what emerged was a highway, the road that Jews have traveled since Biblical days. Constantin Boym, the exhibition designer, himself a Russian émigré, created the installations at each turn of the road to prefigure the exhibition themes: Exodus and Transition, Settlement and Community, Transmission and Regeneration. The idea was that as visitors traverse this paradigmatic pathway, they find themselves on a trans-global receiving line, on which they encounter artists and scribes, scholars and housewives, communal leaders and campers — from medieval Germany to colonial America, from 16th century Mexico to 18th century Ukraine. They reveal themselves to us through their surviving legacies—a manuscript, a cookbook, a portrait, a teddy bear, a Torah Scroll. Next to the object itself are the comments of people who were invited to respond, intellectually or emotionally, to the object. Just as Jews have done through the millennia, they question, challenge, interpret and expand our discussion.

In our time, when collecting has become almost a national pastime, and cultural property a hot legal issue — a time when great fortunes are spent on Judaica — it behooves us to remember the intrinsic meaning of the artifact rather than its monetary value. The partners in the Center share this in common: we cherish our holdings because they demonstrate the ideas, philosophies and outlook of generations of Jews whose heritage it is our mission to preserve. It is this non-hieratical approach that best demonstrates the power of our collective material holdings, not merely to summon up remembrance of things past, but to enable museum visitors to discern the often surprising and unpredictable path of the Jewish journey through time and space.

SYLVIA A. HERSKOWITZ IS THE DIRECTOR OF YESHIVA UNIVERSITY MUSEUM

ACKNOWLEDGEMENTS

The cooperation and creativity of many individuals and organizations helped to make this groundbreaking exhibition a reality. We acknowledge the enthusiasm and support of the Museum Board of Trustees, Erica Jesselson, Chair, and Ted Mirvis, Vice Chair, who encouraged and supported us from the outset, and especially to Lyn Handler, and her husband Jerry, who opened their home to us. We are grateful to the Board, staff, and partner organizations of the Center for Jewish History for their encouragement and affirmation of this project: Bruce Slovin, Chair of the Center, Nancy Polevoy, Chair of the Center Program Committee and Lois Cronholm, Vice-President.

We especially acknowledge the members of our Scholars Committee - headed by Lawrence Schiffman, who shared their expertise and ideas with us: Robert Chazan, Hasia Diner, Robert Engel, David Fishman, Benjamin Gampel, Jeffrey Gurock, Philip Miller, Marion Kaplan and Michael Stanislawski. Special thanks to Professors Schiffman, Diner and Stanislawski for preparing essays for this publication. Our thanks go to all the commentators who provided personal responses to the artifacts in this exhibition, thereby helping us to more fully tell the story of these objects.

Our partner organizations have generously lent their precious artifacts, expertise and enthusiasm to this exhibition project. We recognize their efforts and express our thanks to: American Jewish Historical Society: Michael Feldberg, Director; Risa Loenberg Gewurz, Lyn Slome, Ellen Smith and former staff member Abby Schoolman; American Sephardi Federation: Elizabeth Mizrahi, National Executive Director, and Vivienne Roumani-Denn; Leo Baeck Institute: Carol Kahn Strauss, Executive Director; Renate Evers, Frank Mecklenberg and Renata Stein; YIVO Institute: Carl Rheins, Executive Director; Aviva Astrinsky, Leo Greenbaum, Batya Kaplan, Chana Mlotek, Fruma Mohrer and Marek Web, as well as former personnel Tom Freudenheim, Zachary Baker and Lisa Epstein.

As always, we are blessed with the talents of our colleagues at Yeshiva University. Our special gratitude to University President Dr. Norman Lamm for contributing a significant essay to this publication. We thank Pearl Berger, Dean of Libraries, for her assistance. We also express our thanks to Paul Goldschmidt, University Risk Manager, the University Public Relations Department and Norman Goldberg of the University Photographic Services.

Our talented exhibition designer Constantin Boym and his firm Boym Partners Inc. created the physical embodiment of our exhibition concept. We also acknowledge the graphic artistry of Barbara Glauber and Beverly Joel of Heavy Meta. The exhibition construction was expertly handled by R.H.Guest Exhibit Production. As always, we are indebted to our masterful textile and costume conservator-installer June Bové, to Chris Ketchie, Chief Preparator, and to all our installation staff.

From the earliest planning until long after the exhibition has closed, the efforts of the Yeshiva University Museum staff are indispensable. Sylvia Herskowitz, Director, who originated the exhibition concept and title; Randi Glickberg, Deputy Director; Lois Brandt, Director of Development; Gabriel Goldstein, Curator; Bonni-Dara Michaels, Collections Curator; Reba Wulkan, Contemporary Exhibitions Coordinator; Rachelle Bradt, Curator of Education; Judy Dick, Assistant Curator of Education; Evgeny Steiner, Archivist; Eleanor Chiger, Office Manager; Barbara Goldner, Public Relations Consultant; and, Elan Bosworth, Museum Aide.

Our talented docents deserve recognition for their diligent preparation and study of exhibition contents. We are certain that through their guided tours visitors, both young and old, will better appreciate this exhibition.

We acknowledge the editorial assistance of Kathy Lyons. Our special thanks to Ava Barbour and all of the staff of Barbour Design, Inc. for their elegant design and valuable assistance.

We are indebted to our family of supporters whose generosity and enthusiasm enable Yeshiva University Museum to thrive both in our original galleries on the uptown campus as well as in our new home. We express our appreciation to Mary Smart and The Smart Family Foundation and to the New York State Council on the Arts, Museum Program for demonstrating their commitment to our exhibition by awarding substantial planning grants. The publication of this catalogue has been made possible, in part, by the Lucius N. Littauer Foundation.

MAJOR INTERSECTIONS EXHIBITION TEAM

Sylvia A. Herskowitz, Director, YUM – Project Director
Gabriel M. Goldstein, Curator, YUM – Exhibition Curator
Constantin Boym – Exhibition Designer
Randi R. Glickberg, Deputy Director, YUM – Project Administrator

Exhibition Scholars Committee
Lawrence H. Schiffman, Chair
 Edelman Professor of Hebrew and Judaic Studies
 Chairman, Skirball Department of Hebrew and Judaic Studies, New York University
Robert Chazan, Scheuer Professor of Hebrew and Judaic Studies, New York University
Hasia Diner, Steinberg Professor of American Jewish History, New York University
David Engel, Skirball Professor of Modern Jewish History, New York University
David Fishman, Professor of History, Jewish Theological Seminary
Benjamin Gampel, Associate Professor of History, Jewish Theological Seminary
Jeffrey Gurock, Klaperman Professor of Jewish History, Yeshiva University
Marion Kaplan, Professor of History, Queens College
Philip Miller, Director of the Klau Library, Hebrew Union College – Jewish Institute of Religion
Michael Stanislawski, Nathan J. Miller Professor of History, Columbia University

Laurene Leon Boym, Christine Warren, Boym Partners Inc. – Exhibition Design
Barbara Glauber, Beverly Joel, Heavy Meta – Exhibition Graphics
R.H. Guest – Exhibit Production
JL Construction; Peter H. Billow Fine Woodworking – Exhibition Fabrication
June Bové – Costume and Textiles Conservation and Installation
Chris Ketchie – Chief Preparator
Ava Barbour, Mali Cohen, Barbour Design, Inc. – Publication Design
Lois Brandt, Director of Development, YUM
Bonni-Dara Michaels, Collections Curator, YUM
Reba Wulkan, Contemporary Exhibitions Coordinator, YUM
Rachelle Bradt, Curator of Education, YUM
Judy Dick, Assistant Curator of Education, YUM
Eleanor Chiger, Office Manager, YUM
Barbara Goldner, Public Relations Consultant, YUM
Elan Bosworth, Museum Aide, YUM

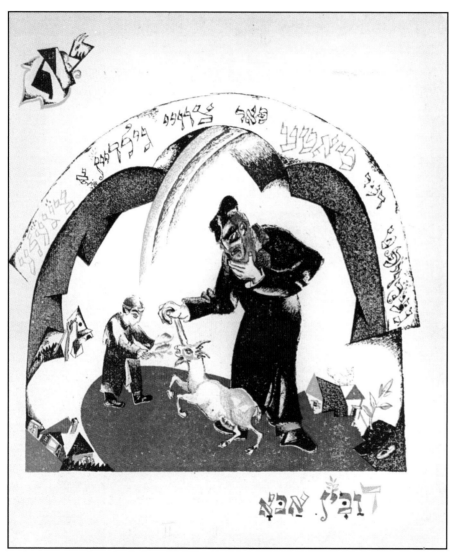

EL LISSITZKY, HAD GADYA (CAT. NO. 1,2)

MAJOR INTERSECTIONS: AN INTRODUCTION

NORMAN LAMM

In welcoming you to this inaugural exhibit by Yeshiva University Museum in its new quarters in the Center for Jewish History, I extend to you the greetings of *shalom ve'achvah*, Peace and Fellowship, on behalf of Yeshiva University and, equally, all the constituent organizations of the Center.

At a time when the essential unity of the Jewish people is threatening to unravel, and the differences amongst us are exacerbated by angry argumentation at progressively increasing decibels, neither Peace nor Fellowship can be taken for granted. There are no simple answers to our problems, and the dilemmas will not pack up and steal away quietly in the dead of night.

But while these troubling issues continue to afflict us, there are certain mitigating factors and certain strategies that we can adopt to ease the consequences of divisiveness and disunity. Our presence in the Center for Jewish History suggests one approach – Jewish history itself. Even the most elementary acquaintance with the story of our people, from Abraham through Moses and Joshua through the two Temples to our own day, reveals that we have behaved with a shocking compound of single-mindedness, disputatiousness, and stubbornness that often deserves the epithet "irresponsible." Yet, as a people we have survived not only the most cruel of oppressors and the most perilous of periods, but also – ourselves. Underneath the oppressive layers of anger and arrogance lies a vast mine of bonding with fellow Jews, a passion for the ideals that nourish all of us in their various mutations, and the readiness to sacrifice for each other – in a word, *ahavat Yisrael*, the love of one Jew for another, which, in turn, is the most basic prerequisite for *ahavat ha-beriyot*, the love of all human beings. Peace and Fellowship are there, waiting for us to tease them out of mere potentiality into functioning reality

This history lesson lies at the heart of this exhibit. We do not minimize the integrity of the parties to any of the ideological quarrels that engage us, and we do not believe that superficial courtesies should be mistaken for full *shalom ve'achvah*. But we can nevertheless work together, live together, and hope together – even argue together. Hence, the principals in this consortium go from the Orthodox to Reform, from Sephardic to Yiddish culture, from the religious to the secular. And we at Yeshiva University Museum are proud to dedicate our initial exhibit at our new quarters to this overarching vision.

THE THREE THEMES

The exhibit we present to our visitors consists of three sections, each to be taken in its very broadest sense. They are: Exodus, Rootedness, and Transmission. This tripartite division, by happy circumstance, reflects the themes inherent in the three paragraphs of Judaism's most sacred proclamation of faith, the *Shema*.

The third paragraph concludes with the words, "I am the Lord your God who brought you out of the land of Egypt to be your God, I am the Lord your God" (Numbers 15:41). The exodus from Egypt is the great paradigm of liberation, of freedom, of release from the land of slavery.

Rootedness is evident through the second paragraph, in such verses as, "And I shall give the rain of your land in its season, and you shall gather in your corn and your wine and your oil..." (Deut. 11:14) or, "So that your days and the days of your children may be multiplied upon the land which the Lord swore to your fathers to give them" (Deut. 11:21). Finally, the theme of transmission is heard in the first (and again in the second quote) "And you shall teach [the words of Torah] diligently unto your children" (Deut. 6:7).

TRENT BLOOD LIBEL MANUSCRIPT (CAT. NO. I,5)

Exodus

Exodus appears as a recurrent theme in Jewish history. The first exodus was that of the Children of Israel from Egypt; most of the other instances of Jewish wandering, unfortunately, were more like the Exodus of the Jews from Palestine to Assyria and, later, Rome and its provinces. The former was an exodus from slavery to freedom, as was the "ingathering of the exiles" to Israel in our own times; the latter was an exodus of exile from independence to servitude and dispersion, as were the expulsions of the Jews from so many European countries. Whether one or the other, we have been a people on the move. "The wandering Jew" became a staple of the mythology about Jews in Christian Europe.

The uncanny ability of Jews to retain their ethnic, national, and religious identity despite the dreadful uncertainties under which they lived for close to 2000 years has become one of the marvels of history. Even when the Dalai Lama came to these shores a few years ago, one of his first requests was to meet with Jewish scholars who could tell him about how Jews lived in the Diaspora so that perhaps the Tibetans might learn to do likewise. The Torah – our spiritual, religious, and

cultural patrimony – became our traveling homeland, one that did not at all displace our geographical homeland, the Land of Israel, but allowed us to survive spiritually and psychologically and to nurture an intense longing for the Land, a yearning and a love that found its support in both Scripture and the Oral Law. Exile and wandering, dislocation and relocation, expulsion and banishment have pock-marked the Jewish experience from the very beginning of its story.

These peregrinations, whether imposed on us by Jew-hatred or beckoned to us by the lure of greater economic and political opportunity, have never been without cost. Many are the souls who were lost to us forever because of the brutality of oppressors or the illusory inducements of assimilation. The Ten Lost Tribes following the destruction of the first Temple were exceeded by the numbers of Jews slaughtered during the terrible years of the Holocaust. Note, for instance, in the current exhibit an interesting but jarring study in contrasts: the original autographed manuscript of "The New Colossus," the famous poem inscribed on the Statue of Liberty, symbol of Jewish freedom and prosperity in America, and the manuscript trial record of the notorious Blood Libel of St. Simon of Trent and, as well, the Displaced Persons' Haggadah of Germany in 1946 (cat. nos. I,10,5 & 4). These are tokens of our wanderings in different ages and different climes. Some were felicitous, most were not. Yet, having paid the cost, we still remained one people.

R o o t e d n e s s

How did we manage to survive all these displacements, whether voluntary or coerced? We did so by learning how to strike roots in foreign soils and alien cultures while retaining our ties to our ancient geographical homeland, the Land of Israel, and continuing to nurture the various elements that constitute our natural and religious identity in a realm that transcends both geography and history. This capacity to live in multiple commitments, no mean feat at all, has caused us great grief at the same time that it became a source of survival and pride. We suffered the charge of "dual loyalties" in this country and elsewhere, and we now look back with some sad amusement at the efforts of many pre-World War II German Jews to declare themselves as "Germans of Mosaic persuasion."

We are fortunate that in America we do not feel compelled to confirm our loyalty to the state by abandoning our identity as Jews – much too high a price for acceptance. Many of the students at Yeshiva University represent a continuation of this threefold thread: loyal American citizens who consider themselves religious Zionists. Hence: roots in America, in Torah, and in Israel. It is not an insignificant achievement, and it is deserving of celebration.

Consider, in this regard, some of the artifacts in this exhibit such as the portrait of U.S. Navy Commodore Uriah P. Levy, or the Minute book of the Burial Society of the Portuguese community of Altona-Hamburg (cat. nos. II,17 & 4).

T r a n s m i s s i o n

None of the above miracles could have taken place without a mechanism for the transmission of Judaism and Jewishness from generation to generation. All of the above – the lessons learned from exile and the dreams and

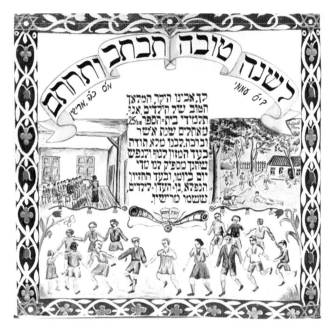

LODZ GHETTO ROSH HASHANAH BOOK (CAT. NO. III,17)

aspirations of rootedness – come to grief if there is no effort at transmitting them to the future. Whether the Jews will become like the Incas – explored by archeologists and examined by antiquarians as they sift through the sands of a lost and once glorious civilization – or remain a vital people nourished by a viable culture and sustained by a vigorous state concerned with the safety and welfare of Jews the world over, all depends on how successful we are in inculcating our values in our children and children's children, handing over to them our history and heritage, our texts and our experiences, with all their glories and agonies, trials and tribulations and, above all, visions.

This act of transmission, this process of education, is carried on in a variety of manners. Formal education is a universally acknowledged Jewish contribution to world culture. Almost two millennia ago, the Sages legislated compulsory education for the young, even as the Torah commanded us to teach Scripture diligently to our children. As the embodiment of what the Sages considered the most significant element in Judaism, teaching Torah, education became the lot of all Jews even with the advent of the Enlightenment. Refracted through the prism of secularism, education as such emerged as the common mark of the contemporary Jewish personality. If we have "made it" in America, it is largely because fundamental to the Jewish heritage and the Jewish psyche is the precept of learning: For the religious Jew, education is a *mitzvah*, for the secular Jew a value.

The mission of Yeshiva University – the parent of the Museum – is to facilitate the transmission of both the pristine Jewish heritage and worldly culture – the humanities, the arts, the sciences – both natural and social, the world of business, and all the components of the higher culture of the Western world, the one in which most Jews of the world find themselves.

But education consists not only of formal texts. There are lessons to be learned and stories to be told also by the artifacts of the past. Just as the basic corpus of Jewish knowledge, in all its vast complexity, is transmitted in a variety of languages – Hebrew and Aramaic, Yiddish and Ladino, and almost all of the modern languages – so is the narrative of Jewish experience and creativity conveyed by things, by objects, by items as diverse as human experience itself. This is the realm in which Yeshiva University Museum has staked its claim for the sake of perpetuation and education,

as a service to the Jewish people and, indeed, to all men and women – and children – curious about the nature and past of this extraordinary people.

One of the more moving items in the collection presented to you, courtesy of our partner YIVO, is a book containing close to 15,000 hand-written signatures of Jewish children and their teachers in the Lodz Ghetto in Poland in 1941 (cat. no. III,17). Most of those children did not live to adulthood; the German *herrenvolk* took care of that. What an awesome object of admiration that book is – a testament of education and transmission, even when the recipients were doomed to extermination.

A people capable of such daring and magnificent dedication – to the point of irrationality – to education can never be eradicated, no matter how powerful the forces arrayed against it. This book is but one token of our passion for learning and the promise of our stubborn commitment to survive any and all vicissitudes and to continue the narrative of the Jewish experience extending from the misty past through the turbulent present to the unknown tomorrow and tomorrows upon tomorrows, in *shalom ve'achvah*.

That too is ultimately what this museum and this exhibit – and this university – is all about.

DR. NORMAN LAMM IS THE PRESIDENT OF YESHIVA UNIVERSITY

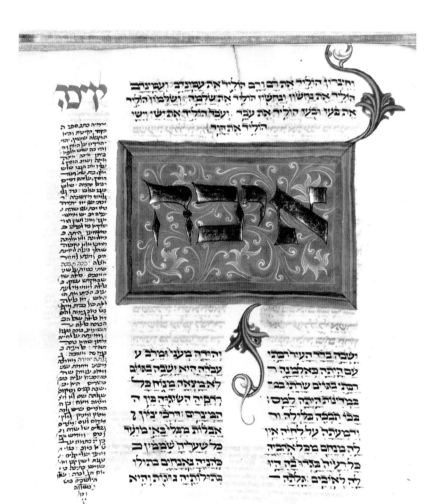

MAJOR INTERSECTIONS: AN OVERVIEW

LAWRENCE H. SCHIFFMAN

EXODUS AND TRANSITION

Jewish existence throughout the ages has been one of motion: geographic, religious and cultural. Jews on the move have passed their tradition from generation to generation and applied it to a variety of new and differing circumstances. This movement has been a major factor in creating "Major Intersections," an exhibit detailing intersections that are likewise spatial, intellectual, political, economic, and religious. Yet throughout the long years of Jewish history, certain fundamental texts and traditions have shaped the way Jews have seen the experiences they have shared and passed on. If there is any text that, together with its physical transmission and its interpretation, symbolizes this sense of continuity, it is the Bible. It is for this reason that our tour of the Jewish experience begins with a brief look at one of the most important manuscripts of the Bible available: the Prague Bible, copied in 1489. This beautiful, decorated manuscript, containing the entire Bible, Torah, Prophets, and Writings – the underpinnings of the Jewish tradition – traveled a path in modern times that is almost symbolic of the ideological wanderings of the modern Jew (cat. nos. I,1; II,1; III,1).

Emerging from Prague at a time when this city was about to become a major center of Ashkenazi intellectual life, this Bible, which also includes the commentary of Rashi (1040-1105), would eventually be owned by the philosopher Moses Mendelssohn (1729-86; see also cat. no. II,15), a major figure in the modernization of the Jews of Germany, and by the Court Jew Daniel Itzig (1723-99; see also cat. no. II,6). It then passed into the hands of the early Reform Jewish scholar Abraham Geiger (1810-74), and after his death, rested in one of Berlin's premier tions of modern Jewish learning, the Hochschule für die Wissenschaft des Judentums, which trained many of Germany's leading reform rabbis. From there, the manuscript eventually found its way to the Orthodox American institution, Yeshiva University.

This journey is what the exhibition seeks to illustrate, the long, winding movement of Jews and Judaism that we illustrate here primarily in its latest stage, from Europe, the Middle East and, to some extent, the Mediterranean basin, to North America and the Land of Israel. But this first example is even more, because it illustrates the varying manifestations of Jewish religious and cultural life, every one of which in some ways traces itself back to the core traditions and experiences of the Jewish people. We include the Pentateuch, including the story of slavery, Exodus, and redemption, in the first part of this exhibit (cat. no. I,1).

The movement we are talking about has sometimes been voluntary, but has often resulted from some form of persecution. In such cases the new home that the Jews established may have provided a sense of liberation. The slavery of the Jews in Egypt and the Exodus to freedom, leading the Jews to the Promised Land, is the historical paradigm for Jews throughout the ages. The festival of Passover, celebrating this ancient Exodus, has often taken on the symbols, and certainly the meaning, of later experiences of Jewish movement. Migration was often precipitated by the push of anti-Jewish

policies, but often encouraged by the pull of a new "Promised Land," as in the case of America – *the Goldene medine*- or of the true promised land, Israel.

The fundamental observance of Passover is the Seder, at which the traditional *haggadah* (telling, or better retelling) is recited. The final song of this evening ritual, the *Had Gadya*, with which the retelling closes, itself illustrates the linguistic intersections of the Jews, for it is in Aramaic, an ancient Near Eastern language spoken by Jews in the early Middle Ages, especially in Babylonia (modern Iraq). Yet the ever developing cultural meaning of this Aramaic song is illustrated beautifully by El Lissitzky's colorful suite of lithographs, based on the verses of this song. The song itself illustrates the sequence of events of Jewish history, leading from slavery to redemption, ultimately tracing the events in a chain to the power of the divine. According to some interpretations, the lithographs transfer this theme to the victory of the Bolsheviks over the anti-Communist "Whites," a now ironic reminder that what one generation may see as liberation may be for another a new slavery (cat. no. I,2).

Every generation has created beautiful *haggadot* for their use. This tradition even continued after the invention of printing, so that the study of decorated *haggadot* can illumine the entire sweep of Jewish history. This *Haggadah* with grisaille (black and white) illustrations demonstrates also the absorption by Jews of the latest artistic styles from the cultures in which they lived (cat. no. I,3). Other circumstances also led to the development of a variety of *haggadot*, such as secularist kibbutz texts and those calling for freedom for Soviet Jewry or referring to issues such as civil rights, vegetarianism, or feminism, all interpreted against the background of the traditional story of slavery, Exodus and freedom.

It was not long after the Bolshevik revolution that Jews faced another in the series of experiences of slavery, but this time in a form more cruel than ever before. The Holocaust would totally reshape the demographic nature of the world Jewish community. Involving the murder of one third of the Jewish people and the displacement of many more, the Holocaust completed a process in which the centers of Jewish life were eventually relocated to North America and Israel. At the end of the war, when the fires of the camps of slaughter had been put out once and for all, the remaining Jews still had the spirit to celebrate the classic liberation of the Jews at Passover and to relate it to their own experience. While the text is forthright in questioning God's role – the hiding of His Presence – in this awful period of Jewish tragedy, the *Survivors' Haggadah* still stands as an eternal monument to the ability of Jews, even after the most dire of experiences, to commemorate the paradigmatic ancient symbol of slavery and freedom (cat. no. I,4).

For Jews, the experience of being pushed out of their homes by anti-Jewish measures was nothing new. Among those incidents that helped to bring to an end the Jewish communities of medieval Europe were a series of blood libels such as that which took place at Trent in Northern Italy. In 1475 the initial accusations were made, and a total of eleven Jews were executed. The record of this trial stands as a monument to the ability of regimes throughout history, and in many geographic localities, to adopt the most anti-Jewish of stances. But, the 1965 de-beatification of the alleged victim of this blood libel offers hope for a better future (cat. no. I,5).

Not long afterward, the Jews of the Iberian Peninsula faced the requirement to convert to Christianity or to leave their homes. Many left, seeking new lives even in the Americas. But even there they were often pursued by the Inquisition, which sought to identify Judaizers among the New Christians (*conversos* or *marranos*). In Mexico City in 1590 such accusations were made against one former Jew, as designated in the document exhibited here, though the accuser eventually recanted (cat. no. I, 6). Such trials are documented as late as 1772, and documents such as this one describe the persecutions the *conversos* continued to suffer even after embracing Catholicism.

In modern times, it was the Holocaust that had the greatest role in causing large-scale Jewish migration. On November 9, 1938, the infamous *Kristallnacht*, synagogues, Jewish shops and homes were fiercely attacked and burned, and the deportation of Jews to concentration camps began. This prayer book, with charred fragments of Torah scroll and wood, which were salvaged from this inferno, gives a sense of reality to an event that presaged the wholesale destruction of European Jewry and its religious and cultural institutions (cat. no. I,8).

One of the major effects of the persecution of Jews in the modern era in Europe was the encouragement of migration to America. To be sure economic factors contributed, but certainly the experience of violent anti-semitism was a major cause of movement for many Jews. Physical testimony to such violence is the set of Sabbath candlesticks exhibited here, which were damaged with a bullet hole in Russia in the 1880s (cat. no. I,7). The daughter of the owner of these candlesticks never recovered from the death of her mother in the same incident. She did, however, immigrate to the United States and bring the candlesticks with her, which she lit every Friday night.

Yet at the same time, immigration to the United States and to Israel were stimulated by the respective advantages of the places of immigration. For many, America, the land of freedom, was paved with gold, but for others, the age-old Jewish dream of the reestablishment of the Jewish homeland in the Land of Israel was an even stronger pull. These two poles would typify Jewish population movement in the late nineteenth and twentieth centuries, just as they continue to do so today, as Jews from various parts of the former Soviet Union make their way to America and Israel.

Already in the earliest stages of its history, the United States was clearly a unique place where the principles of republican democracy and the Bill of Rights would allow Jews to enter society on an equal footing. Among the classic statements of that footing is the letter written by Thomas Jefferson in 1818 in response to the discourse of Mordecai Manuel Noah (1785-1851) at the consecration of the new Spanish and Portuguese Synagogue building in New York (cat. no. I, 9). In his inaugural discourse, Noah surveyed the entire history of the Jews and their sufferings; Jefferson's sympathetic response made clear his commitment to equal rights and to the role of education as the key to the eradication of prejudice. Noah's own distinguished career made clear that although Jews still had to face some prejudices in the New World, it assuredly presented more opportunities than the Old World.

It was no wonder that as economic and political circumstances for Jews deteriorated in Eastern Europe, large-scale emigration to the United States ensued in the 1880s until the close of free immigration in 1924. From the erection of

Sonnets.

I.

The New Colossus.

Not like the brazen giant of Greek fame,
With conquering limbs astride from land to land
Here at our sea-washed, sunset gates shall stand
A mighty woman with a torch, whose flame
Is the imprisoned lightning, and her name
Mother of Exiles. From her beacon-hand
Glows world-wide welcome; her mild eyes command
The air-bridged harbor that twin cities frame.

"Keep, ancient lands, your storied pomp!" cries she
With silent lips. "Give me your tired, your poor,
Your huddled masses yearning to breathe free,
The wretched refuse of your teeming shore.
Send these, the homeless, tempest-tost to me,
I lift my lamp beside the golden door!"

1883.

(Written in aid of Bartholdi Pedestal Fund.)

the Statue of Liberty in 1886, its torch of liberty was a welcoming sign to millions of immigrants. Even though the Statue was originally not intended for this purpose, it became a symbol of the American welcome to immigrants and the notion of a safe haven and personal liberty in America. These concepts also underlay the poem "The New Colossus" by Emma Lazarus (1849-87), first affixed to the Statue in 1903 and from 1945 displayed in its current position. For those Jewish immigrants who were processed at Ellis Island, so close to the Statue of Liberty, all the sacrifices of immigration were worthwhile so long as the hopes and dreams represented by the Statue could be realized in America. A copy of "The New Colossus" in Emma Lazarus' own handwriting is preserved in her notebook (cat. no. I, 10).

Many of the Jews who made the arduous journey to reestablish themselves in America were unable to take their entire families. Often, the men went first, leaving wives and children behind in the old country to await earning the steerage to bring them to America, as well as to establish a sufficient economic base to enable the family to live in the new land of freedom. Most of these Eastern European Jews spoke Yiddish as their mother tongue. Here is a lullaby, the text of which was composed by the great Yiddish author Sholem Aleichem, who actually annotated this copy in his own hand (cat. no. I, 11). In the lullaby, a mother comforts her baby whose father has already left for America.

As American immigration was intensifying in the 1880s, so too was the pull of the Land of Israel. The organized Zionist movement, emphasizing as it did the need to colonize Palestine and to establish a Jewish political entity there, was deeply rooted in the age-old Jewish dream of reestablishing the homeland in Israel. The core of this dream was the city of Jerusalem, symbolizing the greatness of the Jewish past and the potential for an even greater future in an old-new land.

Throughout the ages, the fascination with Jerusalem spawned an entire variety of art. Pictures of the holy city adorned Jewish homes, often as indicators of the *mizrach* (East), the direction towards which Jews in most parts of Europe prayed in an effort to face Israel. Interest in the Holy Land among Christians also encouraged the parallel development among Jews in the United States. In the 1880s, an otherwise unknown Jewish craftsman lovingly built a model of Jerusalem in Ann Arbor, Michigan. We can imagine him working on his model, hoping that the real rebuilding of the city would soon follow (cat. no. I, 13).

Much more well known was Theodor Herzl (1860-1904) whose stirring slogan, "If you will it, it is not a dream," galvanized the Zionist movement and its dream of rebuilding a Jewish national state in the Land of Israel. His notebook from 1882-7 stems from his student days (cat. no. I, 12). It offers a sense of the incipient search that would eventually lead him to embrace Jewish nationalism in the aftermath of the Dreyfus affair, which demonstrated the power of anti-semitism, even in enlightened, modern France.

As we have seen in this section, the theme of Exodus, whether caused by persecution or the allure of a better life elsewhere, is a recurring aspect of Jewish life. The first Exodus was from slavery to freedom, from Egypt to the Land of Israel. Later wanderings were often associated with exile from the land, as in the Babylonian exile, or the return to it as in the ingathering of the exiles in modern times. Whatever the case, Jews have been a people on the move. The process of moving and of reestablishing themselves in new places and cultures was a constant source of fructification, a creative and transformative influence that challenged and enriched the Jews and their culture. For many American Jews, the experience of persecution or expulsion and its resonance in their understanding of Jewish historical experience has propelled them into lives of social action and liberal politics.

The uncanny ability of Jews to maintain their ethnic, national, and religious identity despite the dreadful uncertainties under which they lived for close to 2000 years has been regarded as a marvel of history. Clearly, the religious tradition and the culture of the Jews became a traveling homeland that reflected in turn the intersections of geography and culture that the Jewish people experienced.

Settlement and Community

The long trips that Jews took from the "old country," wherever it might have been, to new homes meant the onset of a period of adaptation and adoption. Jews had to adapt themselves and their religious institutions to a new environment, while trying to preserve as much as possible of the old. Yet all kinds of new strategies had to be adopted for the purpose of maintaining the heritage of Judaism, however that heritage may have been seen by the different actors in this ongoing drama. Our exhibit has examined this process in three spheres of life faced by Jews wherever they established themselves: home and family, community organizations, and the synagogue. While various clichés place the key to Jewish continuity over the ages in one of these spheres, it is clear that the intersection and interaction of these realms and a variety of other factors have combined to preserve the Jewish heritage throughout the ages. To be sure, Jewish interaction with the general community was a fundamental sign of the welcome that Jews received, which often made it possible for Jews to make major contributions to the countries in which they lived.

For Jews in ancient times, exile and resettlement in their new homes in the Diaspora are described in the biblical Prophets. Accordingly, we begin this section with the second volume of the Prague Bible, that of the Prophets (cat. no. II, 1).

For most Jews religious practice and food intersected first at the level of *kashrut*, the laws of kosher food: the separa-

tion of meat and milk, and the slaughtering, butchering, and salting of meat to avoid the consumption of blood or forbidden fats. Throughout history, from Talmudic times on, rabbinic authorities had to arrange for the proper supervision of kosher food, and often the various struggles or even conflicts over *kashrut* are an important key to understanding the internal developments of a Jewish community. The renowned Rabbi Yitzhak Elhanan Spektor (1817-96), for whom Yeshiva University's rabbinical school is named, like so many other prominent rabbis, played a role in kosher supervision, as we see in his certificate included here. Rokeach soap was important to kosher consumers because it was the only dishwashing soap not made with nonkosher ingredients and because it was marked with blue and red dots for dairy and meat dishes. This soap was a staple of Jewish home life in Europe and America until it was superseded by modern detergents and the advent of the dishwasher (cat. no. II, 8).

Whether for the purpose of maintaining the culinary traditions of the home or for passing them on to a new generation, what could be more important than cookbooks? These texts, such as the handwritten, private cookbook shown here from Frankfurt in 1891, were compiled for private use by individual women (cat. no. II, 9). Even after cookbooks began to be published and sold, recipes continued to be collected and written out by hand for private family use. Each woman prided herself on her own "Jewish" cooking, which, of course, represented the cuisine of the region from which her ancestors had come, sometimes closely resembling the cuisine of the non-Jewish population of that area. When Jews arrived in new regions, they quickly used and adapted cookbooks to their own use, so as to be able to cook their traditional dishes in the new environment and also so as to adopt the culinary heritage of their new homeland. Often, the so-called Jewish cuisine entered the wider culture and enriched the diet of the non-Jewish population as well. Jews have always prided themselves on the setting of the table for Sabbath and Festival meals. Jewish law requires that the table be set before the candles are lit on Sabbath and Festival eves. Tablecloths were considered obligatory. Their decoration was often a matter of great pride, reflecting the decorative arts and styles of the various places Jews lived, but often displaying particularly Jewish themes and even prayers such as the *kiddush* (cat. no. II, 7).

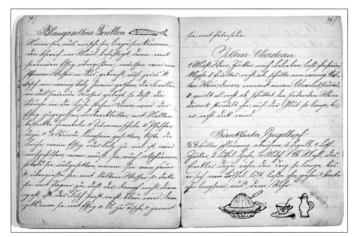

HOCHSTAEDTER COOKBOOK (CAT. NO. II,9)

But the home was much more than food. Many Jewish women made clothes for their families, and Jewish men and women were deeply involved in the needle trades, espe-

cially in the United States where they played a leading role in unionizing this industry. This work was greatly eased by the automation provided by the sewing machine; this Singer model came replete with instructions in Ladino, the language of those Jews whose ancestors had migrated after the expulsion of the Jews from Spain in 1492 and had settled in the Ottoman Empire (Turkey). This instruction book illustrates the importance of Jewish languages as transmitters of culture, a constant feature of Jewish life (cat. no. II, 10).

Aristocratic families tended often to adopt the general practices of the people among whom they lived, and an example of this is the autograph book of Rebecca Itzig (1763-1857), daughter of the Court Jew Daniel Itzig (cat. no. II, 6; see also cat. no. I,1). Various family members signed its pages; such books may have served as entertainment at family gatherings. But the baptism of Rebecca's husband David Ephraim indicates that even with all the accoutrements of the traditional Jewish home, modernization and assimilation would still have a major impact on the Jews in their new places of settlement.

Throughout Jewish history, numerous forms of communal organizations have evolved to maintain the Jewish community and its heritage. Such organizations always betray in their structure and their affairs the changing environments in which Jews lived, and the intersection of history with the ongoing obligations of the Jewish polity, itself in the process of moving from a compulsory to a voluntary body in modern times as a result of emancipation.

For most Jews, the extent of communal organization and autonomy they might experience was local. Local communities all kept *pinkasim*, records of their decisions, as well as of births, marriages, and deaths. That of Skoudas (Yiddish, *Shkud*) in Lithuania, covering the seventeenth through the nineteenth centuries, is typical of these record books, which demonstrate the extent to which communal cohesiveness was a key factor in Jewish survival in what was to a great extent an alien and even antagonistic society (cat. no. II, 2). One of the things that emerges from study of documents such as this one is the complexity of the organization of the local Jewish communities. It is no doubt the plethora of officials, institutions, and societies, however they may have been set up in the various countries and regions of the Diaspora, that made Jewish community life possible.

Among the organizations that served every Jewish community were those that took upon themselves the task of helping the poor and sick, or raising money to provide dowries or burial expenses for those in need. Such societies were often called *hevrot* or *gemilat hesed* (doing of good deeds) societies. While male members of the community undertook certain responsibilities, much of the charity work was in the hands of women. These societies flourished in all the "old countries" from which Jews came to America, so it was to be expected that in every Jewish community established in this country, from the poorest to the richest, women would continue to play a central role in fulfilling the Jewish obligations of charity. The Homeler Ladies Aid Society was established in Harlem by immigrants from Homel, a town near Minsk in what is now Belarus. Such societies maintained the links of former townspeople – *landsmann* – and the societies were called *landsmannschaften*. The 1926 Record Book of the Homeler Society, which lists all its members and their spouses, testifies to its important charitable work (cat. no. II, 5). The role of women in such tasks was

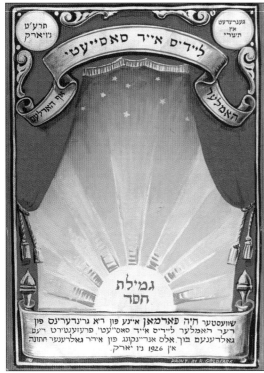

Within the image (Yiddish/Hebrew text):

תרע׳ט ניו יארק · גענרירעט אין תשרי

ליידיס אייד סאסייעטי

האמעלער · האמלער

גמילת חסד

שוועסטער חיה פֿארמאן איינע פֿון רי גרינדערינס פֿון
דער האמלער ליידיס אייד סאסי׳יעטי פֿרעזענטירט דעם
גאלדענעם בוך אלס אנדיינקונג פֿון אירר גאלדענער חתונה
אין 1926 ניו יארק.

PAINT. BY R. GOLDFARB

HOMELER LADIES AID SOCIETY OF HARLEM (CAT. NO. II,5)

greatly spurred by the American tradition of female volunteerism and the result was a vast network of American Jewish women's organizations that have done so much vital work.

Another essential organization that Jews had to establish wherever they went was the burial society, because Jewish ritual required that a dead body be specially prepared and buried in a Jewish cemetery according to Jewish practice. Furthermore, burial societies helped the dead in their last moments of life on this earth and comforted the mourners. Often these societies provided burial to the indigent who had nowhere else to turn. One such society was that of the eighteenth century Portuguese Jewish community in Hamburg-Altona whose minute book has survived (cat. no. II,4). This community, originating in *conversos* who returned to Judaism after migrating out of reach of the Inquisition, represented a Sephardic community in Germany, demonstrating the ever-continuing intersection of Ashkenazic and Sephardic communities, today a feature of Jewish life in almost every major center.

Another particular community that demonstrated the intersection of cultures was that of Provence, where France and Spain meet, geographically, culturally, and Jewishly. The community of Carpentras was one of four with a special prayer liturgy and distinctive synagogue architecture particular to this region. It was also in this area that many *marrano* Jews were able to return to Jewish practice. The seventeenth century record book of the Provençal community of Carpentras records births, circumcisions, marriages, and deaths, testifying to the concern of the Jewish community for each of its members (cat. no. II,3).

Needless to say, the synagogue, the central organ of Jewish ritual life, was a major locus of communal activity throughout Jewish history wherever Jews were to be found. Synagogue architecture represented a blending of the ritual requirements of construction, the traditional architecture of the areas from which the Jews in a given locale had originally come, and the prevailing architecture in vogue at the time, often influenced by that of non-Jewish places of worship. As such, synagogue appearances reflected intersections along both historical and geographic axes.

When Jews from the Iberian Peninsula made their way to Amsterdam to escape the Inquisition and their own forced

conversion to Catholicism, it was natural that their synagogues should represent their unique mixture of historical and cultural heritage. Built in 1671-5, the Portuguese Synagogue of Amsterdam set the standard for all later Spanish-Portuguese houses of worship (cat. no. II,11). Its architecture was partially influenced by that of the Protestant churches of Holland. From Amsterdam this heritage was carried to North America, to New York and Montreal, where Spanish-Portuguese synagogues still exist. When a synagogue was designed for Lingolsheim, near Strasbourg, ca.1862, it likewise represented a blending of traditions and styles. Its plan draws on Jewish tradition, as well as on local Alsatian architecture, including features best known from church buildings (cat. no. II, 12).

Aspects of synagogue architecture and decoration have a venerable tradition in Jewish history. This is the case with the pair of lions, probably derived from the Cherubim mentioned in the Bible as shielding the Ark in the Tabernacle and Solomonic Temple. Such lions are found as early as the fourth century C.E. synagogues of the ancient Land of Israel. They are found throughout North America as well, having been brought from Europe. Often the craftsmen who made such synagogue decorations had been trained in this art in Europe (cat. no. II, 13).

One of the most obvious demonstrations of the way in which Jews interact with their respective surroundings, whether accepting or rejecting the norms they present, is to investigate the many portraits of modern Jews preserved in so many collections. We have selected a few portraits to remind us, as we complete this section of the exhibit, of the many faces of modernity and the different ways in which they affected different Jews.

Bilhah Abigail Franks (1696-1756) was a Jew of great loyalty to her people who, despite her best efforts, saw some of her children marry non-Jews, given the situation in colonial America (cat. no. II,14). Uriah Phillips Levy (1792-1862) was able to rise to the highest rank in the U.S. Navy, while opposing the punishment of flogging and suffering accusations motivated by anti-semitism (cat. no. II,17). His loyalty to and love for the United States led him to devote himself to the restoration of Thomas Jefferson's estate Monticello. Both of these portraits illustrate the tensions and the opportunities that America presented, but the risks to Jewish identity were by no means to be gainsaid. The set of daguerrotype portraits of Selina Seixas Moses (1838-1917) doc-

MODEL OF THE PORTUGUESE SYNAGOGUE, AMSTERDAM (CAT. NO. II,11)

uments the growing up of a young Jewish woman in nineteenth century America (cat. no. II,20).

Central to the debate over Jewish modernity, both in his own time and even today, is Moses Mendelssohn (1729-86). This traditionally observant Jew was at the center of the philosophical world of Germany and proposed a specific approach to Judaism that radically shifted its relationship to the dominant society, advocating much further integration than had heretofore been the norm for German Jewry. While this approach was in reality a symptom of the onset of modernity and the breakdown of Jewish separateness, it was blamed by many in the Orthodox world for the weakening of traditional Judaism. Most of Mendelssohn's descendants converted to Christianity (cat. no. II,15; see also cat. no. I,1).

A group of four family portraits also indicates the widespread changes that took place in the lives of many European Jews as a result of the enlightenment and the entry of Jews into mainstream culture and society. We have no idea who painted these portraits or who the subjects are. The shift from traditional Jewish dress to modern European costume can be seen clearly; also note the lack of a beard on the younger man, who covers his head, perhaps in accord with Jewish tradition or perhaps following the mores of the general culture. The change in women's attire is also evident (cat. no. II, 16). Yet the Jews of Eastern Europe and the eastern parts of Central Europe were much slower to change, as can be seen in the portraits of Cantor and Mrs. Hirsch Kurtzig and Rabbi and Mrs. Zuckermann (cat. nos. II,18-19). These mid-nineteenth century images, like so many such portraits, show that modernity reached Eastern Europe more slowly, but by the onset of the Holocaust modernity had already had profound effects in this region as well.

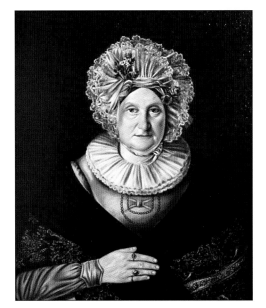

PORTRAIT OF MRS. KURTZIG (CAT. NO. II,18)

How did Jews manage to survive all the displacements they experienced, whether voluntary or coerced? They learned how to strike roots in foreign soils and cultures while at the same time maintaining their distinctive ties to their ancient homeland, the Land of Israel, and continuing to nurture their national and religious identity. This tension – another form of intersection – between concrete and even cultural rootedness and temporary status – had advantages and disadvantages to Jews throughout the ages. Nonetheless, it sustained the Jewish people wherever they settled, allowing the development of the complex and varied communal cultures that expressed Jewish identity in all the lands of the dispersion and the contribution of the Jews to the wider society, whenever and wherever it was welcome.

TRANSMISSION AND REGENERATION

In this section we explore four facets of the complex mission Jews had to fulfill in every generation and in every locale, the passing

on of their varied and manifold tradition to the next generation. This task was often made much harder precisely because of the factors we explored earlier: the movement of population, with the attendant interruption of orderly processes and the need to set up new communal structures in newly settled communities. A number of strategies were developed in every such situation, which once again demonstrate the intersections of the old and the new and of the various locales in which Jews and Judaism flourished. We explore here the centrality of the Torah as a symbol of the Jewish tradition that grew up around it. Further, we illustrate the role of Jewish languages in the transmission of culture, the way in which lifestyle events contributed to the ongoing intergenerational intersection without which the Jews, their religion, and culture would never have survived, and the role of education as the central transmitter of Jewish culture.

We open this section with the third volume of the Prague Bible, the Writings, which symbolizes the ongoing development of Jewish tradition already in the biblical period (cat. no. III,1). It is this section of the Hebrew Scriptures that points forward to the great classics of post-biblical Hebrew literature.

Wherever Jews went they carried the Torah (the Five Books of Moses) with them – literally. Whereas the rest of the Bible, except for the Scroll of Esther, was for most Jewish communities only a codex (a bound book), the Torah had to be a scroll, copied by a scribe in an ancient style and script. Only such a text had the necessary religious authority and authenticity to be used for public reading in the synagogue, a ceremony that was effectively an acting out of the giving of the Torah at Sinai and the passing on of the tradition to the next generation. Torah scrolls came in various sizes and external forms, but the text was the same and all Jews treated it with utmost respect.

The Torah scroll shown here belonged to Rabbi Israel Baal Shem Tov (1698 or 1700-1760), the first leader of the Hasidic movement. He is often termed the founder of Hasidism, despite the fact that this movement had roots in the previous century. This great lover of God and his fellow Jews preached simple piety, joy in fulfilling the law, and the immanence of God in this world. He laid the foundations for a movement that would sweep over most of Eastern Europe before relocating in America and Israel, a process that was completed as a result of the Holocaust. In this movement we have the transmission into modern times of the teachings of the Kabbalah, in many ways modified and popularized (cat. no. III,2).

Torah scrolls, as we mentioned, were treated with particular respect. Hence, they had to be kept in the specially constructed Holy Ark (*Aron Kodesh*), which represented the Ark of the Covenant from the period of Israel's wandering in the desert after the Exodus, when the Ten Commandments and, according to rabbinic tradition, the Torah as well, lay in the Ark. As expected, Arks were made in every place according to different artistic tradition. But sometimes they were made for particular purposes, like the Jewish Chaplain's portable Ark used during World War II and in the DP camps where the survivors of the Holocaust were gathered after the war (cat. no. III,4). This ark, with its wooden *rimmonim*(Torah finials) must have symbolized to Rabbi Joseph Shubow (1899-1969), who carried it on his Jeep, and even more to the survivors who worshipped in front of it, the permanence of the Torah and Jewish tradition even in the aftermath of the horrors they had suffered. Yet at the same time, its portability symbolized the constant movement of the Jews and their culture, as had the original Ark in the Tabernacle of the desert period after the Exodus. After World War II, the

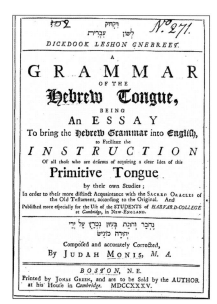



J. MONIS, DICKDOOK LESHON GNEBREET (CAT. NO. III,11)

Jewish Cultural Reconstruction recovered this Torah crown, one of many "orphan" Judaica objects whose owners and whose communities had been destroyed by the Nazis (cat. no. III,3). It is testimony to the fact that anti-semitism drove not only Jews, but even their religious and cultural objects, to take up new places of residence.

For Jews the languages they used were the result of the complex cultural intersections they had experienced. At the core of Jewish culture and religion was, of course, the Hebrew language. This language itself, in its closeness to the other Semitic languages, testifies to the ancient Near Eastern context of the origins of Judaism. Further, it has been influenced through the years by many languages, starting with Aramaic and running through Greek, Arabic, Russian, and even English. But for many, biblical Hebrew was regarded as the pure tongue and for this reason it was studied widely by Christians in early America. Judah Monis (1683-1764), a Jew who arrived in the colonies in 1720, began teaching Hebrew at Harvard after his conversion to Christianity. The title of his grammar, including the word Gnebreet, is evidence of the Spanish-Portuguese pronunciation of *Ivrit*, the designation in Hebrew for the Hebrew language. His grammar became a mainstay of the study of biblical Hebrew by American Christians (cat. no. III,11).

Jewish history has left its mark in numerous inscriptions, in Hebrew and in all the languages used by Jews throughout the world, ranging in time from the period of the Ancient Israelite monarchy until the most recent found on tombstones or building dedication inscriptions. Such texts can be an important part in uncovering aspects of Jewish history otherwise not known from literary texts, or in fleshing out our understanding with concrete evidence. This ancient Hebrew jar handle inscription mentioning the King indicates that the produce contained in the jar had been paid as a royal tax, and shows us how agricultural taxes were levied in Ancient Israel (cat. no. III,8).

Central to traditional Jewish identity was the study of the Talmud. The Babylonian Talmud, which emerged from the study of the Mishnah (the basic code of rabbinic law) in Iraq in the third through seventh centuries was written in alternating sections of Hebrew or Aramaic, a Semitic language close to Hebrew that was the spoken language of many Jews in late antiquity. The Rothschild manuscript of the Tractate *Bava Kamma*, passed down in the Rothschild family for close to a century, is symbolic of the Jewish dedication to the study of the Talmud and the role that such study has had in the transmission of the Jewish heritage (cat. no. III,10).

It is ironic that the distinguished Hebraist Eliyahu Bahur Levita (1468 or 1469-1549), who spent most of his life in Italy, was author of one of the earliest Yiddish popular books to be printed in the sixteenth century (cat. no. III, 9). This book shows that Yiddish, a dialect of middle high German used by Jews exclusively, which contains an admixture of Hebrew

and Slavic words, penetrated even into Italy. Yiddish, like the other Jewish (Judeo-) languages, itself represents the intersection of the non-Jewish vernacular and the Jewish community, with cultural, religious, and linguistic baggage. But in the nineteenth century an entire secular culture was created in this language, which nurtured a large part of East European Jewry, some of whom had left traditional observance while others still maintained it.

In the United States, Yiddish penetrated into the popular culture, and was a major influence on the rise of the American entertainment industry. American culture and its tragedies were also often expressed in Yiddish, even in music. An example of this is the sheet music for the Yiddish song *Hurban Titanic* ("The Destruction of the Titanic"), which depicts Ida and Isador Strauss, owner of Macy's, who died in this terrible disaster in 1912. Ida Strauss refused to enter a lifeboat with women and children, unwilling to leave her beloved husband behind (cat. no. III,12).

Yiddish theatre entertained generations of East European Jewish immigrants, contributing to the development of American musical theatre, also centered in New York. Yiddish theatre helped make possible the acculturation of its audiences and provided them with the opportunity to feel as if they were still living in a place where Yiddish and its culture were dominant, thus sustaining, for many of them, their secular Jewish identity. Molly Picon (1898-1992) performed internationally, including South America; this 1932 poster is from Buenos Aires, Argentina, a center of Yiddish language and culture (cat. no. III,14).

Throughout the Jewish world, rabbinic courts functioned to deal with matters of personal status (marriage, divorce, and conversion) and to adjudicate financial disputes among Jews. The records of the Salonika Beit Din testify to the vitality of this independent Jewish community, which preserved its culture and the Ladino language of the exiles from Spain in 1492 up until its destruction at the hands of the Nazis in the Holocaust (cat. no. III,13).

The Jewish life cycle was a series of opportunities for the individual Jew to identify with his or her heritage, either by passing through the stages, sharing in its celebrations, or mourning the loss of those Jews who had already passed through this cycle. This aspect of Jewish life is illustrated here by a few items. German Jews have a special custom of creating a Torah *Wimpel* (a cloth wrap that binds the Torah scroll under its mantle). From the sixteenth century, these Torah binders were made from infants' swaddling cloths used at the circumcision ceremony *(brit milah)*. After World War II, this custom was transferred to the German émigré community of upper Manhattan and some German Jews in the United States still maintain it (cat. no. III,5). These *Wimpels* are a testimony to the presence in every Jewish community of its own particular varieties of the life cycle celebrations, which have enriched Jewish life through the centuries.

ALEF-BET CHART (CAT. NO. III, 15)

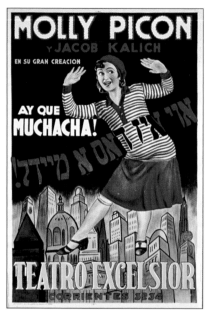

**POSTER; OY IZ DOS A MAYDEL
(CAT. NO. III,14)**

The central role of circumcision as a rite of passage and sign of the divine covenant in Jewish tradition should not allow us to forget about the technical, medical aspects of the rite, which have to be performed at the highest level of cleanliness and safety. Accordingly, special kits were produced or assembled by the *mohalim* (ritual circumcisers). These were often beautifully decorated, as is the case with this early American set, which includes a circumcision guard made by the famed silversmith Myer Myers (1723-95), at one time president of New York's Spanish and Portuguese Synagogue (cat. no. III,6). Jews carried these skills and the requisite equipment wherever they went, so as to be able to usher their newborn sons into the covenant of Abraham on the eighth day as the Torah requires.

Marriage and family were the means to ensure continuity of the Jewish people and their culture and religion. Jews of every locale had their own customs and costumes for this important occasion, not to mention special foods. This was especially the case with the Jews of the Middle East where brides had prescribed costumes. In some communities special dresses were worn by brides on the procession to the *mikvah* (the ritual bath). The examples of bridal dresses shown here from North Africa, the Ottoman Empire and New York City indicate the extent to which these dresses have taken up the styles of the cultures in which the Jews lived, which is certainly the case with wedding attire throughout the Jewish world (cat. no. III,7).

We close the exhibit with Jewish education, always the key to Jewish identity and continuity. Jewish educational experiences come in a variety of forms, formal and informal. All of these together, in their different eras, made use of dominant cultural forms and thus illustrate the intersection of the Jewish and general cultures, while at the same time being at the center of the preservation of the Jewish heritage.

Jewish education was even carried out under the direst of circumstances, as in the Lodz Ghetto where close to 15,000 schoolchildren and more than 700 teachers prepared a book of signatures and drawings, arranged alphabetically by school, to commemorate Rosh Hashanah 5702 in Fall 1941 (cat. no. III,17). Children can celebrate even in the worst of times. Their schools were closed by the Nazis in 1942, and most of the children and teachers were taken to death camps soon after.

Modern Yiddish culture was transmitted in Camp Boiberik, the Golden Book of which we exhibit (cat. no. III,19). Summer camps in this country and abroad have long served as an extremely important aspect of informal Jewish education for all groups in the Jewish community.

Toys of a Jewish character are also an important way Jews transmit their heritage, and these were made in a DP Camp in Trani, Italy, by stateless Jewish girls, some of whom clearly looked toward immigration to Palestine, if we can judge from the toys they made (cat. no. III,18). Various Alef Bet charts have been used throughout history to teach Hebrew letters to young children (cat. no. III,15). But higher education has always been the secret to Jewish cultural and religious development, as exemplified by a document from the Vaad ha-Yeshivot, the committee for yeshivas founded in Eastern Europe (cat. no. III,16). This proclamation, calling for financial support for the yeshivas in the interwar period, was made in Vilna in 1928 and is signed by 85 distinguished East European rabbis, including Rabbi Israel Meir ha-Kohen Kagan (1838-1933), known as the Hafetz Hayyim for his stress on avoiding gossip. He authored the famed *Mishnah Berurah*, an authoritative commentary on the code of Jewish ritual law.

All of these strategies are aspects of one theme, the transmission of Jewish religion and culture from generation to generation. Jews transmitted the experiences of slavery, Exodus, redemption, and community as well as the classical teachings of the Bible about God, Israel, and Torah. Throughout the centuries, the Jews remained a vibrant people, sustained by a vigorous struggle for identity and continuity on the one hand, and for physical survival on the other. Whether formal or informal, religious or secular, these and many other approaches to Jewish Education have one goal: creating intersections across time and space, between Jews over generations, and throughout the world.

Epilogue

Jews have experienced a variety of challenges throughout the centuries, especially in the modern period, which lies at the center of this exhibit. These challenges have been daunting and have often come from hostile quarters bent on destroying the Jewish people physically. At other times, the challenges involved developing strategies for living in new and varied circumstances, for setting up communities, homes, and institutions for passing on Jewish teachings and identity while tending to the needs of the community. Each period had its specific needs, and in each the intersections developed or experienced by the Jews presented opportunities for living as a Jew in a new environment, while the Jewish community took root and participated in the culture of that environment. But the question has always been the same: Wherein lies the secret of Jewish survival, and how can education, religion, and culture intersect in a creative manner to ensure the future of the Jewish people?

LAWRENCE H. SCHIFFMAN IS THE EDELMAN PROFESSOR OF HEBREW AND JUDAIC STUDIES AND THE CHAIRMAN OF THE SKIRBALL DEPARTMENT OF HEBREW AND JUDAIC STUDIES, NEW YORK UNIVERSITY

DESIGNER'S STATEMENT

Designing the exhibition Major Intersections was a particularly rewarding and challenging work. Being a Russian émigré myself (I came to this country in 1981), I was able to reflect on many of the experiences and sentiments of the exhibition as if it was my own personal journey. As books and objects evoked feelings and recollections, I became aware of the challenge of exhibiting them in the Museum galleries. Many Jewish artifacts are visually humble and unprepossessing. In order to go beyond appearances, to hear the objects reveal their deeper meaning and memory, the Museum invited commentators to choose an artifact and to speak about it in a personal way. From the beginning, I imagined these responses as shadows. While the object is immutable, its interpretations are shadow-like: fleeting, multiple, ever-changing. Accompanied by a shadow rectangle, each work in the exhibition effectively becomes a diptych. This device allows for a more complex, multi-layered perception of works of art and history.

Like everything in America, this exhibition is built with metal stud wall construction. Usually the studs are hidden inside walls. Here, they are often left exposed to become an expressive element of the installation. Together with color, space, and light, they work to create a distinct metaphorical setting for each section of the exhibition. Exodus represents a darkened, somber passage. Walls appear to be broken, suspended, uprooted. Emotionally, they evoke drama and uncertainty of transition. We move towards the light, where the silhouette of Jerusalem is visible at a distance.

Rootedness has at its center an image of a building - a house or a synagogue - in the process of construction. We still continue to build our home. Here, the top of stud walls remains unfinished, suggesting continuity and growth. One metal stud has taken root and spread branches, like a growing tree. Open space creates the feeling of a small town square. Glowing colors of sky and sun add up to an affirmative, optimistic image.

In Transmission, translucent partitions express interpenetration between different aspects and generations of Jewish culture and tradition. This section has no walls. Metal studs are left completely exposed. Together with the shelves, they create an image of a warehouse, a place where we store and use our shared knowledge and culture.

CONSTANTIN BOYM, EXHIBITION DESIGNER FOR MAJOR INTERSECTIONS, IS A PRINCIPAL OF BOYM PARTNERS INC.

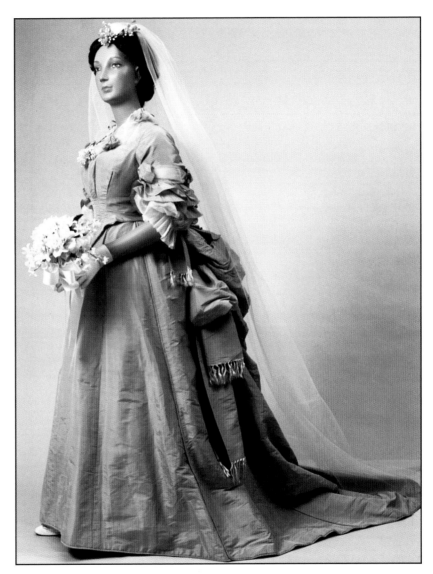

BRIDAL DRESS, NEW YORK, 1874-1878 (CAT. NO. III,7)

I. Exodus and Transition

GABRIEL M. GOLDSTEIN

The famed biblical instruction *lekh lekha* — "Go forth from your native land" (Genesis 12:1) demanded that Abraham uproot himself and head for a new home. Throughout the millennia the process of changing venues has been formative to Jewish identity. As we moved from Egypt to the Promised Land, from Judea to the Rivers of Babylon, or from Minsk to Ellis Island, wandering has often been synonymous with our experience and identity as Jews.

The Exodus from Egypt and the transformative nation-building in the Wilderness are the paradigmatic Jewish experience of relocation and identity creation. As we recount at the Passover seder, "In each and every generation we must see ourselves as if we left Egypt." And, in almost every generation we have encountered enslavement – we have fled to safety in new lands, attempting to escape persecution or physical destruction, or we have been forced out, physically expelled from our homes and forced to move on.

Throughout the centuries, Jews have faced Jerusalem in their prayers and in their dreams. Many have been privileged to retrace our father Abraham's voyage from Ur-kasdim to Canaan and have returned to our ancestral soil. We do not merely travel to the Holy Land; we ascend.

We have journeyed to our homeland as pilgrims from our ancient diaspora homes to celebrate the festivals in Jerusalem, or we have left the urban comfort and sophistication of modern European cities to drain swamps and build a future. We have seen our love of Zion and our longing for our homeland transformed first into a political movement, and ultimately into a nation state. As Jews from "the four corners of the earth" — from Yemen to Uzbekistan — have made aliyah to the State of Israel, we have seen a hint of the Ingathering, the massive messianic repatriation of world Jewry.

In every generation we have longed for Zion – our Promised Land. Yet we have also been drawn to other lands of promise, by the allure of new prospects and freedoms. In an effort to escape poverty, army draft, or bloodthirsty hoards, so many of our ancestors journeyed to the New World, seeking to build new lives for themselves and their children. America beckoned, as a land of independence and opportunity. The concepts of political liberty and religious freedom upon which the United States is based have been a powerful inspiration to Jews throughout the world.

The fabled economic prosperity to be found on gold-paved streets drew many others to the *Goldene medine*. The story of the massive influx of Eastern European Jews greeted by the Statue of Liberty is often told, yet it does not provide a complete and accurate portrayal of the peregrinations and arrival of American Jewry. In 1654, twenty-three Jews fleeing Portuguese rule in Brazil first landed in New Amsterdam; in the three centuries since, they have been followed by successive waves of Jewish immigrants – individuals and families all hoping for a better life.

Faced with political turmoil or anti-semitic legislation in the Old Country, Jews packed up their belongings and came to these shores — from Central Europe, the Pale of Settlement and the Ottoman Empire, and more recently, amidst continuing geopolitical upheaval, from Iran or the former Soviet Union. Many boarded ships that landed at Ellis Island, but others docked in New Orleans, San Francisco, or Gainesville, or continued to points West, in search of California gold or Colorado mountain air to assuage diseases contracted in New York City sweatshops. The New World stretches far beyond the confines of the United States, and some Jews sought opportunities as fur traders in northern Canada or as coffee growers in Panama. As Jews left the Old World for new opportunities and freedoms, or simply in a quest for survival, their new terrains spanned the continents — well beyond Memphis and Winnipeg — to Melbourne, Cape Town, and Shanghai.

In the past centuries, we have often been drawn to the sophistication of urban settings; we left towns and villages in order to experience the cosmopolitan pleasures of Istanbul, Vienna, New York, or Tel Aviv. In turn, we abandoned the cities in search of suburban comfort or rural serenity. Our physical relocations have often been attempts to not only cross borders, but to climb ladders of opportunity and achievement.

Aboard railroads and steamships our grandparents and great-grandparents continued a process begun on foot and on camelback millennia ago. In our own generation, we have witnessed this journey continue, as Jews from Russia and Ethiopia have boarded airplanes and sought new homes. It is well known that the biblical text describes the Children of Israel's deliverance from Egypt with four terms: "I will bring you out . . .and deliver you . . . I will redeem you . . . and I will take you to be My people" (Exodus 6:6-7). Our physical relocation is intrinsic not only to the creation of our identity as a people, but ultimately to our redemption. It is by our journeys that the world will know us and, perhaps even more importantly, that we will know ourselves.

GABRIEL M. GOLDSTEIN IS THE CURATOR OF YESHIVA UNIVERSITY MUSEUM

I. Exodus and Transition

I, 1
The Prague Bible - Volume I: The Pentateuch
Prague, 1489
Scribe: Mattiyah ben Jonah of Luna
Ink, gouache and gold leaf on uterine vellum
Mendel Gottesman Rare Book and Manuscript Collection, Yeshiva University

This is the oldest dated Hebrew manuscript written in Prague. It is bound in three volumes, containing the Pentateuch, the Prophets and the Writings, and is illuminated with gold leaf and colorful foliate scrolls. This Bible has an extraordinary provenance: it was written in the house of Israel Pinchas of Prague and was later acquired by a Königsberg community leader, who presented it to the philosopher Moses Mendelssohn (1729-1786). Its next owner was the Berlin Court Jew Daniel Itzig (1723-1799), and it was later owned by Abraham Geiger (1810-1874), seminal leader of Reform Judaism. Before World War II, it was in the library of Berlin's Hochschule für die Wissenschaft des Judentums.
— see also cat. nos. II,1; II,6; II,15; and III,1

I, 2
El Lissitzky (1890-1941)
Had Gadya Suite, 1919
Color lithograph on paper
Collection of YIVO Institute

Lissitzky, like many artists of his circle, sought to create a modern Jewish art style. His compositions for this suite of ten prints combine various aspects of cubist and futurist art vocabulary with traditional Jewish folk art motifs. Lissitzky may have understood the traditional Passover seder song *Had Gadya* as an allegory of the survival and ultimate triumph of Good over Evil, analogous to the victory of the Bolsheviks over the anti-Communist Whites. Lissitzky's work uses traditional themes and motifs, imbuing them with modern stylistic approaches and contemporary political significance, indicating the timeless nature of the themes celebrated at Passover.

Few works of graphic art have been the object of so much commentary as Lissitzky's Had Gadya. His ten splendid lithographs of the seder song tell the story of a series of assailants who consume each other until the final one, the Angel of Death, is destroyed by God. Jewish Lissitzky scholars tend to see in this story a

parable of the Russian revolution. Both Alan Birholz in his PhD dissertation of 1973 and Ruth Apter-Gabriel, in an essay published in 1987, take this position. Apter-Gabriel believes that Lissitzky substituted the redemptive power of the Communist Revolution for the power of God as it is described in the story.

When I was writing a chapter on Lissitzky's early work for a book on the avant-garde, I had difficulty with the assertions of my predecessors that Lissitzky unequivocally supported the revolution. A simple look at the historical facts shows Lenin's intention to reduce or eradicate the identities of nationalities and his creation of a Jewish Bolshevik organization, the Evsektsiya, that was charged with eliminating the Yiddish cultural milieu of which Lissitzky was an active participant. What further dissuaded me was the ambiguity of Lissitzky's statements about his non-objective Proun paintings. If he were supportive of the revolution and had created Had Gadya to express that position, why would he not be more clear about the meaning of his paintings, which he began the same year? I concluded that Lissitzky's reluctance to define the Prouns as political parables was due to his ambivalence about the revolution. He was caught between the affirmation of a new secular Yiddish culture and the Bolshevik government's attempts to eradicate it. My interpretation is based on the argument that not all members of the avant-garde had the same stake in the revolution, and therefore not all shared a common belief in its value.

Victor Margolin
Professor of Design History, University of Illinois, Chicago

I, 3
Haggadah
Scribe-artist: Eliezer Zusman Magrytsh
Hamburg, 1831/2
Ink and gouache on vellum
Collection of Yeshiva University Museum. Gift of Samuel Sondheim in memory of his wife Rita Sondheim, née Silberberg, his son Eli, and his father-in-law Herbert Silberberg.

In the 18th century, Hebrew manuscript illumination flourished in Germanic lands, experiencing a revival after the invention of printing. *Haggadot* were particularly popular, and were often modeled after well known printed editions. This trend continued into the 19th century, as seen in this example from Hamburg, with grisaille (black and white or grey tonal) illustrations.

I ,4
Survivors' Haggadah
Munich, 1946
Written, designed and illustrated by Yosef Dov (Ber)
Sheinson (1907-1990)
Woodcuts by Miklós Adler (1909-1965)
Printed by the US Army of Occupation
Collection of the American Jewish Historical Society

This *Haggadah* was created by and for Holocaust survivors for their first Passover after liberation from the Nazi death camps. It draws powerful parallels between the biblical Passover experience and its creators' own Holocaust era enslavement and liberation.

The *Survivors' Haggadah* was first printed at a former Nazi-supporter printing house in exchange for cigarettes and food, using zinc plates and Hebrew and Yiddish type secured by American Jewish organizations. It was then taken to Army chaplain Rabbi Abraham J. Klausner, who arranged for it to be officially printed by the U.S. Third Army on better paper with a tricolor "A" on its cover, the insignia of the Third Army — the Army of Occupation for Southern Germany. Klausner used this *Haggadah* at seders held at the Deutsches Theatre Restaurant in Munich, attended by survivors, Allied military forces and representatives of government and civilian aid agencies. This copy of the *Haggadah* belonged to Rabbi Klausner himself.

FLIGHT

I, 5
Prozess gegen die Juden von Trient (The Trial of the Jews of Trent)
Trent , 1478-1479
Ink, gouache and gold on paper
Collection of Yeshiva University Museum

This is the only German trial record of one of the most infamous ritual murder accusations of the Middle Ages. In 1475, following the fiery anti-semitic Lenten sermons delivered by the Franciscan monk Bernardino da Feltre, the body of a Christian infant named Simon was discovered near the house of the head of the Jewish community of Trent. This document records "confessions" of seventeen of the accused Jews, extracted after fifteen days of torture.

I, 6
Inquisition Trial Document of Miguel Hernandez de Almeida
Mexico City, 1590
Collection of the American Jewish Historical Society

In Spain, legal proceedings against suspected Crypto-Jews (Jews who outwardly converted to Christianity, but secretly maintained Jewish practice) began in the 15th century. In the 16th century, the Inquisition followed the Spanish conquerors to the New World, where trials continued until the end of the 18th century. Almeida's trial ended abruptly when the principal witness against him recanted and confessed to being a liar.

The Alameda Central, adjacent to the Palacio de las Bellas Artes, is Mexico City's most prominent downtown park. Immortalized in a mural by Diego Rivera, and the site of numerous films and novels, it is especially popular among adolescents in love, who stroll on lazy Sunday afternoons as they are about to engage in their first kiss. Few of them know that the place they stand on once housed the infamous Plaza de Quemadero – in colonial Spanish, quemadero meant "human bonfire" – where the Holy Office of the Inquisition engaged in public burnings against scores of crypto-Jews and other heretics between 1596 and 1771. A plaque, almost impossible to locate, commemorates their martyrdom. Is the size of that plaque, around 10 1/2 by 15 inches, a measure of Mexico's amnesia about the role Spanish Jews played in its history? How long will it take for people in the country to come to terms with the age of religious intolerance that is at its foundation? The concept of purity of blood ruined many lives in the Hispanic Americas, particularly among the New Christians. This game of double appearance – are you truly whom you pretend to be? – remains undisclosed in textbooks, and with it the trials of Diego Núñez da Silva in Peru and Don Luis de Carvajal the Young in Mexico.

Jews too are partners in this amnesia, of course. The betrothal of my own grandparents, Yiddish speakers from Eastern Europe who arrived in the 1920s, took place at the Alameda Central. A photograph of them kissing is in the family album. They never bothered to find out, even after the shot was taken, what other pledges the park has been a stage to.

Ilan Stavans
Critic, Professor of Spanish, Amherst College

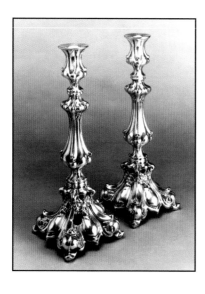

I, 7
Sabbath Candlesticks with Bullet Hole
Warsaw, 19th century
Silver
Collection of the American Jewish Historical Society
Gift of Priscilla Pitcher

Purchased by her mother in St. Petersburg in the late 19th century, Edis Cetebrenick Grossman and her husband Jacob, a merchant and clothing manufacturer, kept these Sabbath candlesticks in their Kiev home. In the late 1880s, during an anti-Jewish uprising, one of Jacob's factory employees raced to the Grossman home to warn the family. Rioters followed and fatally shot the employee as he was leaving the house. Another bullet struck Edis' mother, who died the next day. A last bullet ripped through one of the candlesticks, leaving a visible reminder of the Russian pogrom.

In 1892 the Grossmans sailed for America, bringing their samovar, some textiles, crystal, and silver, and these candlesticks. In Boston, they reconstructed their lives, using these candlesticks each Shabbat.

I, 8
Prayerbook and charred fragments salvaged after Kristallnacht
Berlin, 1938
Collection of Leo Baeck Institute

After *Kristallnacht* (November 9-10, 1938), this prayerbook (*Siddur Sephat Emeth,* Frankfurt, 1935) was salvaged from the ruins of the Pestalozzi Strasse Synagogue in Berlin by Marianne Salinger, along with charred fragments of a Torah scroll and wood from the Ark. The Pestalozzi Strasse synagogue was one of 289 German synagogues burnt to the ground on *Kristallnacht.*

A few days after the notorious Kristallnacht, I climbed through a broken side window inside our synagogue. There was total destruction and desolation. The Torah scrolls had been unfurled and thrown into the Aron Kodesh (Holy Ark). I managed to break off a small piece of a Torah, as well as the charred wood surrounding it.

The elderly Shammes (sexton) came in and watched what I was doing, but said nothing. He was a kindly man who always gave me a good prayerbook, not torn or frayed. I often wondered and feared what has

become of him, as well as of our cantor, Katz Cohen, whose heavenly voice made services at the Pestalozzi Strasse Synagogue a spiritual experience for my lifetime.

May these small burnt remnants serve as a remembrance to this congregation in Berlin and the shame of Gemany.

Marianne L. Salinger
Kristallnacht Survivor

ALLURE

I, 9
Letter from Thomas Jefferson to M.M. Noah
Monticello, May 28, 1818
Collection of Yeshiva University Museum

In 1818, Mordecai Manuel Noah (1785-1851), a political activist, playwright, journalist and drama critic, and the recognized leader of early 19th century American Jewry, delivered a discourse at the consecration of Congregation Shearith Israel's new synagogue building in New York. In his discourse, Noah recounted the vicissitudes of Jewish history, and analyzed the Jewish role in building America and the responsibilities of American Jews. Noah sent copies of his address to leading Americans, including former President Thomas Jefferson (1743-1826). Jefferson responded with this letter, in which we can glimpse his intellectual integrity and compassionate nature. Jefferson denounces anti-semitism, and affirms education as the means by which religious prejudice will be eliminated.

I, 10
Emma Lazarus (1849-1887)
"The New Colossus"
New York, 1883
Holograph copy in her manuscript book, Original Poems by Emma Lazarus
Collection of the American Jewish Historical Society

A descendent of several of America's oldest Jewish families, poet, essayist, political activist, and eloquent advocate for immigrants, Emma Lazarus wrote "The New Colossus" for an 1883 New York City auction to raise money to complete the base of the Statue of Liberty. The whereabouts of the auctioned copy are unknown, but Lazarus also recorded the sonnet on the first page of a notebook of her writings. The poem remained almost forgotten until 1903, when it was installed on a bronze tablet inside the statue's pedestal. There it remained relatively unnoticed until the late 1930s

when Yugoslavian-American journalist Louis Adamic incorporated verses from it into virtually everything he wrote on the plight of Eastern European refugees. His writings propelled the poem into national consciousness, and in 1945 the tablet was moved to the main entrance of the Statue where visitors see it today.

Though the Statue of Liberty was designed to look away from America toward Europe, the source of liberty, Lazarus interpreted the Statue as a welcome to America, the new source of liberty. Lazarus' understanding redefined the world's understanding of this national symbol.

It is Emma Lazarus' fate to be remembered for her "The New Colossus," welcoming the "tired," the "poor," the "huddled masses," "the wretched refuse" of ancient lands, "homeless" and "tempest-tost." There has come down to us a national memory of three migrations. First, the Protestant English of New England. The standard of living, if you like, of these seventeenth-century folk was as near to subsistence as life allows, but they leave no memory of destitution. To the contrary, the higher faculties and finer things preoccupy them at all times. The Pilgrims, two months and five days outbound from Plymouth, pause before setting ashore, to draw up a charter guaranteeing manhood suffrage.

Next (or simultaneously, really) is the forced migration of Africans in the slave trade, with its pervasive aggression and horror. (We tend to overlook the large, important, entirely free migration of Caribbean and Central American blacks.)

Then came the Irish, followed by the central and southern Europeans, mostly Catholic and Jewish. And oh, what a sorry bunch and what a sorrowful time that was.

Nonsense. The 20-million-odd immigrants who arrived between 1870 and 1910 were not the wretched refuse of anybody's shores. They were extraordinary, enterprising, and self-sufficient folk who knew exactly what they were doing, and doing it quite on their own, thank you very much. Just as important, the Europe they left behind had attained a general degree of civility and legality unknown in its history. If political rights were not always advanced, civil rights generally were. In 1861, the Italians had pulled off the Risorgimento, a brilliant democratic coup with scarcely a drop of blood shed. The newcomers did not learn the rule of law in New York: More likely, they noticed a regression.

One of them was my grandfather Jack. As best we know, he came over from County Kerry just over 100 years ago. I doubt he took much notice of Miss Liberty, still not quite finished. He would have gone through Castle Clinton, as Ellis Island was a few years away.

In any event, he was headed straight for Jamestown, New York, where he had relatives. He got a job digging ditches for the new gas pipelines then being laid. Got to be a foreman after a while. Dug his way to a

*small town on the banks of the Wabash and fig-
ured that was far enough. Became the first
Catholic president of the Moose - there has to be
a first of everything - and so far as I remember,
to the day he died, never once mentioned being
tired.*

*Daniel Patrick Moynihan
United States Senator*

I, 11
Sholem Aleichem
(Shalom Rabinovitz, 1859-1916)
"Shlouf Mein Kind"
— with annotations in the author's own hand
Odessa, 1892
Collection of YIVO Institute

Sholem Aleichem, the famed Yiddish author, dramatist and humorist, wrote this poignant lullaby sung by a mother to her child whose father has gone to America. This published copy features annotations in the author's own hand

I, 12
Notebook and Diary of Theodor Herzl
Vienna, 1882-1887
Collection of YIVO Institute

This notebook covers Herzl's last two years of university study and the early literary and legal career of the founder of the Zionist movement. The majority of the notebook pages consist of notes and comments on books read in 1882. Beginning in 1883, this notebook was used as a diary, and it indicates Herzl's personal search for direction and meaning, before his well-known awakening to the cause of Jewish Nationalism following the Dreyfus Affair of 1894.

I, 13
Model of the Old City of Jerusalem
Maker: Moses Kernoosh (dates unknown)
Ann Arbor, Michigan, ca. 1880
Wood, cardboard, tin, wire, paint, rice paper
Collection of the American Jewish Historical Society

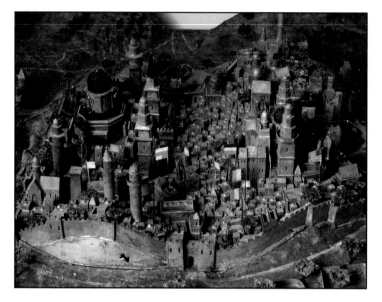

Not much is known about the history of this unusually fine model of Jerusalem, constructed by Moses Kernoosh, a plumber, in his home during evenings and free time in the early 1880s. In its original form the model was labeled, each building and significant site numbered to correspond to a now-lost key. Much of the siting and scale of the model is accurate, but some of the sites are incorrectly located, and certain distances are foreshortened, suggesting that Kernoosh worked from published photographs that also foreshortened the landscape. The specific images that Kernoosh consulted remain unknown. Interest in the Holy Land rose significantly among American and European Jews toward the end of the 19th century. Kernoosh was one of many American Jews captivated by these new images and stories; his personal expression of connection to the Holy Land is extraordinary.

American Zionism has always been an imaginative enterprise. Despite the complex array of organizations, fundraising campaigns, and formal activities that comprise the American Zionist movement, American Jews have retained personal and idiosyncratic attachments to Zion. Why would a late-nineteenth century plumber from Michigan build his own model of the Old City? Was he imagining the ancient city of the Jews or dreaming of a Zionist future? What meanings did he find as he constructed this intricately detailed replica of Jerusalem? Did he ever intend to visit, much less to move to, the city of Jerusalem or was he building a comfortable life in America, devoting his leisure time to this creative project? Whatever his motivations, this model was certainly his way of "knowing" Jerusalem and by creating it with his own hands, making it his own. In contrast to the ownership and hands-on building of the halutzim (pioneers), this is the vicarious, imaginative possession of an American Jew. Within the unknown motivations of this nineteenth-century amateur artist lie the complexities of American Zionism, embodied in a midwestern Jew who meticulously constructed his own connections to the Holy Land.

Beth S. Wenger
Katz Family Chair in American Jewish History, University of Pennsylvania

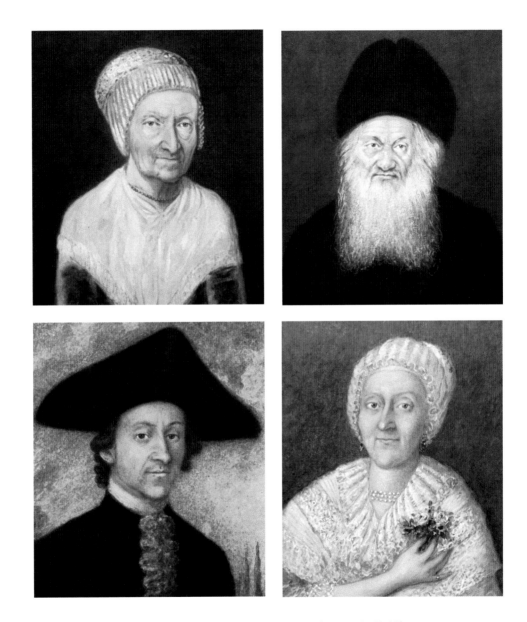

FOUR FAMILY PORTAITS, GERMANY, CA. 1780-1800 (CAT. NO. II,16)

II. Rootedness and Community

HASIA R. DINER

The prophet Jeremiah sent a letter to Jerusalem's exiles living in Babylonia. Rather than pine for Judea, he exhorted them to put down new roots, reconcile themselves to the place where they now found themselves, the land on the banks of the Euphrates, and reconstruct their lives as Jews. There they should, he commanded, "build houses and dwell in them, plant gardens and eat of their fruit" (Jeremiah 29:5). Though taken to Babylon by force as captives of a foreign enemy, Jeremiah told the sons and daughters of a once-promised land, that they must now "seek the peace of the city...and pray for it" (Jeremiah 29:7), making this their home.

They listened to him. They constructed homes there, refashioned social institutions, experimented with cultural practices, and transformed a place of exile into a coherent community where they lived among people different than themselves. In this adaptation to a new place, they deftly balanced their identities and behaviors as heirs to a tradition that stretched back to Sinai, with the styles, tropes, and tones of the culture that flourished between the Tigris and the Euphrates rivers.

In admonishing them to build dwelling places, cultivate the soil, and link their fate with that of the people of Babylonia, the biblical narrative focused on home and homes. Babylonia was to be their new home. Their destiny would now be bound up with its well being, and they would enjoy peace and prosperity if the city itself did so too. The women and men who had once been Judeans became Babylonian Jews. They would act in relationship to both parts of their identity. Both would define who they were. However, as much as they might yearn to return someday to Zion, the very act of building and planting represented a commitment to a new place. By virtue of expending time and energy on houses and gardens, they made a statement about where they envisioned their future.

In Babylonia they also created homes for their families and homes for their communal institutions. In these two kinds of homes, the domestic and the public, they constantly kept Jewish practice alive by hewing to the dictates of the past and improvising with the opportunities and exigencies of the present.

In the process of putting down Babylonian roots, building Babylonian houses, and planting gardens appropriate to Babylonia's soil, they became part of a new and complicated public culture. By doing this they not only obeyed the divine voice, but set a pattern for subsequent Jewish migrations.

The story of this exile and adaptation as told by Jeremiah repeated itself regularly, indeed universally, in the long course of Jewish history, and in each moment of transplantation, Jews did what their forbears had done in that far distant, almost mythic, past.

A half millennium later another imperial power, Rome, cast them into another diaspora, and once again they recreated homes and communities, and by redefining the nature of their tradition, they made themselves at home in multiple places scattered around the Mediterranean world. This second exile was then followed by compelled expulsions from many places – Spain, Portugal, communities up and down the Rhineland – and voluntary migrations, from west to east and from east to west, continuing through the end of the twentieth century. In that long history of diaspora, Jews came to make their homes on virtually every continent.

In each move they re-enacted the same drama and went through the same creative process: find new land, build their homes, construct new communities as homes for their public lives, and adapt to their surroundings, always being mindful of where they had once been and where they now found themselves.

Some elements of their home life were always there, and whether it was twelfth-century Spain, eighteenth-century America, nineteenth-century Galicia, or twentieth-century Lithuania, Jewish practices and idioms bore a striking resemblance to one another regardless of where they were played out. In all those places the family served as the prime locus for Jewish life and the most powerful engine for enculturation. How parents defined their obligations to their children and how husbands and wives engaged with each other grew out of an obedience to and reverence for Jewish practice. By the foods they ate and the ways they marked time, distinguishing between sacred and mundane, between Jewish and gentile, they made their domestic spaces into sites for the reproduction of culture.

The elusiveness and near invisibility of boundaries between Jewish homes and Jewish communities also characterized their lives wherever they settled. That *kehillot* assumed a common range of responsibilities for their members, ensuring a minimum standard of existence, providing a decent Jewish burial, offering a modicum of protection, and enabling Jews to engage with the realm of the spirit through religious worship linked Jews wherever and whenever they lived.

In every home, Hungary, Germany, the United States, Turkey, Provence, Poland, common elements – Sabbath, holidays, *kashrut, gemilat hesed, taharah, mikvah*, worship in the synagogue, and the public reading of the Torah – represented a Jewish core. The catholicity of these practices erased time and place. Sabbath was Sabbath whether in Homel or Hamburg, Lancaster or Lyons, Amsterdam or New Amsterdam, York or New York. The rites of burial differed little from century to century. Their *ketubbot*, wedding contracts, spoke in a universal Jewish language.

But each act of transplantation added to the corpus of Jewish culture, elaborated upon the core and took Jewish life in novel directions, creating time – and place – specific variations. Wherever they settled they had to accommodate to the environment in which they found themselves. New languages were added to their repertoire. Jews in the French-speaking world became French speakers, American Jews spoke English, Jews living in the Germanic lands took upon themselves German. Yiddish and Ladino embodied the idea of a Jewish linguistic fusion, the blending of Jewish modes of expression with, and in, the tongues of their non-Jewish neighbors. Similarly new styles of dress, new ingredients for their foods, new designs for their houses of worship, and new rules and regulations promulgated by the larger soci-

ety pushed Jewish practice into forms that made sense in these places and for these times.

Indeed, wherever they settled, they chose to accommodate and find ways to be part of their host culture, at least as far as those unfolding possibilities did not jeopardize that which Judaism and Jewish life demanded of them. Certainly Jews debated amongst themselves, in polemics and through their actual behavior, as to what those demands were and how far they might accommodate without jeopardizing the integrity of Jewish life. Those debates heated up by the end of the eighteenth century as prospects for integration and acceptance loomed as real possibilities. The greater the opportunities for Jewish integration into larger societal frameworks, the more intense the controversy over boundaries. The more welcoming the environment, the more powerful the pressures upon Jews to identify with the common culture.

But in each of their homes – whether in the Mediterranean basin of late antiquity, the medieval period characterized by self-governing Jewish communities, the early modern period dominated by the rise of the absolutist state, the modern age that witnessed the triumph of emancipation, or the postmodern world that encourages experimentation and multiple renegotiations of identity – Jews tested the boundaries between themselves and their neighbors, and took upon themselves, as Jews, elements of the world in which they lived.

In all the places they lived, over the course of millennia, they built communities that they hoped would endure for generations. They sought ways to make themselves useful to the people they lived with, to prove that they had indeed sought "the peace of the city" and that their gardens had borne fruit for themselves and their neighbors. They hoped to build homes and be at home in them.

HASIA R. DINER IS THE PAUL S. AND SYLVIA STEINBERG PROFESSOR OF
AMERICAN JEWISH HISTORY, NEW YORK UNIVERSITY

II. ROOTEDNESS AND COMMUNITY

II, 1
The Prague Bible - Volume II: The Prophets
Prague, 1489
Scribe: Mattiyah ben Jonah of Luna
Ink, gouache and gold leaf on uterine vellum
Mendel Gottesman Rare Book and Manuscript Collection, Yeshiva University
— see cat. no. I,1; see also cat. nos. II,6 and II,15.

II, 2
Pinkas Shkud
Communal Register of the Jewish Community of Skuodas, Lithuania
17th through 19th century
Collection of YIVO Institute

The town of Skuodas (*Shkud* in Yiddish) is situated in northern Lithuania, on the Latvian border. Its Jewish community constituted more than 60% of the town's population throughout the 19th century, but declined in the interwar period. The entire local Jewish community was annihilated during the Holocaust. This community register was used by the *Shkud* community for centuries, and was expanded when necessary, by sewing additional leaves into the volume.

II, 3
Commual Register of the Jewish Community of Carpentras
Carpentras, France, 18th century
Collection of YIVO Institute

These are fragmentary pages of Hebrew entries recording births, circumcisions, marriages and deaths. Carpentras is one of four communities in the region to maintain a distinct, local liturgical rite (*nusakh*).

II, 4
Record Book of the Burial Society of the Portuguese Community of Altona
Hamburg-Altona, 1774-1787
Collection of Leo Baeck Institute

This Spanish language record book records the activities of the *Sta. Hirmandade de Hesed Vhemet* (the burial society) of *K[ehilat] K[odesh] Neve Salom*, the Sephardic community of Altona. Beginning in the 16th century, many *conversos* moved to Hamburg and nearby Altona in order to return to outward Jewish practice and to be involved in local and international finance and trade.

II, 5
Golden Book of the Loan Fund of the Homeler Ladies Aid Society of Harlem
New York, 1926
Ink and gouache on paper
Collection of YIVO Institute

The Homeler Society was founded by former residents of Homel, a city in Bielorussia, near Minsk. This book contains a list of Society members and their spouses, and was sponsored by Chaya Farbman on the occasion of her Golden Wedding Anniversary. The frontispiece was painted by R. Rosenfarb.

H O M E

II, 6
Album Amicorum of Rebecca Itzig
Berlin, 1784-1790
Ink and gouache on paper
Collection of Leo Baeck Institute

Rebbecca Itzig (1763-1857) was the daughter of the prominent Court Jews Daniel Itzig (1723-1799). An *album amicorum* is a friend's book, akin to an autograph book, a type of personal manuscript popular among the German educated classes from the 16th century. Such books were filled with scenes of university towns, portraits of friends, tributes and poems, and provided a sense of continuity and memory for their owners. This manuscript contains many greetings from the members of Itzig's family and from her broader circle of family members of Court Jews. Gouache portraits of Rebecca Itzig and Benjamin Friedländer are included in this album, as is an unidentified silhouette of a

young woman. Rebecca was married to David Ephraim, son of the Court Jew Veitel Heine Ephraim, who wrote a page in this album in 1784. David Ephraim was later baptized in Vienna, and changed his name to Johann Andreas Schmidt. — see also cat. no. I,1

Rebecca Itzig Ephraim, I gaze at your portrait, painted in Berlin over two centuries into the past. The leather album in which we find the picture was begun just weeks after your marriage to David Ephraim, on June 3, 1784. You were 21, and he was 22. Your image shows little trace of traditional Jewish life habits. Perhaps only the bonnet tied over your long curls is a concession to the practice of women covering their hair once married.

Your siblings and aunts and uncles and nieces and nephews who wrote their greetings in this album belonged to a charmed circle of the rich and the cultivated. Your husband's grandfather Veitel Heine Ephraim and your father Daniel Itzig had been the leading coin millionaires of their day. Their wealth bought large palaces in the center of town with paintings on the walls, country estates with garden theaters, and nature paths adorned with statues. You and your nine sisters were frequently among the lucky Jewish women then who found a way to public influence, often by leading salons. And your father and brothers were involved in enlightened projects to reform Jewish education.

* But your own life story shows how difficult it was to become modern whilst remaining Jewish in the Berlin of these decades. Your husband David was involved in a financial scandal during the Napoleonic War years, fled Berlin for Vienna, converted to Christianity, and became Johann Andreas Schmidt. You too converted and so did your son Julius and your daughter Jette. Two nephews on the Ephraim side also converted in these years, as did your Itzig niece Leah Salomon and your Itzig nephew Julius Eduard Hitzig. Indeed it so happened that by the time you died in 1847 most of the Itzig descendants were no longer Jewish. Your older sister Sarah Itzig Levy, who did remain Jewish, lamented when she was old that she felt like a "tree without any leaves."*

Were we able to communicate across the years that divide our lives, there is much I would like to discuss with you. I wonder how much choice you had in your marriage to David Ephraim. I wonder whether you and your husband would have converted had it not been for his financial scandal. I wonder if your family debated on the various ways to become rich in your day. Did you all agree that making profits from supplying the armies of Prussia's enemies was a good idea? I wonder especially about how your family regarded your conversion. Were you reviled and rejected by Itzigs and Ephraims who were still Jewish? Or was the transition out of Judaism made easier by relatives who were also converting or at least considering conversion? If you could visit our world now, it might give you some pleasure to wander the halls of your grandfather-

in-law's restored palace on the Muehlendamm in the newly reunited Berlin. Then we could sit in a café near the old Ephraim mansion, and I could tell you what happened to Jews in Germany during the century after you died in 1847. Then you would understand why we today look back with so much alarm at your life choices. For we cannot help but wonder if the fate of Jews in Germany had been different if the elites had not abandoned Judaism, in your time and later. Then, after you get some idea of all the sadness that came to pass after you died, perhaps you will see why it is that Jews today still ponder about your dilemma, which was how to be modern and Jewish at the same time.

Deborah Hertz
Professor of History, Sarah Lawrence College

II, 7
Tablecover for Sabbaths and Festivals
Germany or Italy, 1787/8
Cotton: printed
Collection of Yeshiva University Museum

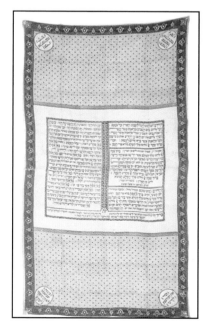

This highly unusual printed textile was used in San Daniele and Padua, Italy. It features the complete text of *kiddush* for Sabbaths and Festivals, as well as the text of Eruv Tavshilin, recited to allow food preparation on a Festival when the next day is Sabbath.

II, 8
Certificate of Kashrut for Rokeach Soap
Rabbi Yitzhak Elhanan Spektor (1817-1896)
Kaunas (Kovno), Lithuania, 1882
Collection of Yeshiva University Museum. Gift of Monroe and Florence Nash in honr of Eric G. Freudenstein.

Rabbi Yisroel Rokeach, a businessman who resided in Kovno, found a way to produce kosher soap for use in washing dishes. Rokeach maintained a close, personal relationship with Rabbi Spektor, the famed *Rosh Yeshivah*, rabbinic authority and community leader. In 1880, Rokeach asked Rabbi Spektor to grant a *hekhser* (kashrut certificate) for this soap. Rabbi Spektor first asked for a chemical analysis to be made. Although the analysis showed

the product to be kosher, the rabbi still feared that people would be confused and might come to believe that all soaps could be used to wash dishes.

To avoid this problem, Rabbi Spektor asked that the name of the product be marked on each bar. Satisfied with this solution, Rabbi Spektor wrote a *hekhsher* for the soap. It is believed to be the only *hekhsher* issued by Rabbi Yitzhak Elhanan. Rabbi Rokeach cherished the document, and attributed the success of his business to Rabbi Yitzhak Elhanan's spiritual support.

II, 9
Cookbook of Rosalie Hochstaedter
Frankfurt, 1891
Collection of Leo Baeck Institute

This meticulously handwritten cookbook features typically Germanic kosher recipes. The recipes for blue poached trout, *wein-chadeau* and *Frankfurter-Gugelhopf* are accompanied by small drawings. Rosalie Hochstaedter was born in Butzbach, Hesse, and later lived in Wuerzburg and Frankfurt.

Handwritten cookbooks are more than the mere safekeeping of recipes. They are a record of the history of a family. It was a common custom to give one's daughter a handwritten family cookbook as a wedding gift. Rosalie Hochstaedter of Frankfurt was clearly a person of means – and creativity. Not only did she write her recipes in perfect script, the sign of an upper middle class person, but she added charming drawings like the gugelhopf with a pitcher and a teacup. Gugelhopf was "the" buttery yeast coffeecake served every Shabbos morning after schule in southern Germany, usually with a tea service similar to the one she drew. The recipe, originally Alsatian, was also eaten to break the fast of Yom Kippur.

The pareve wein chadeau, a typical wine sauce made with 8 egg yolks and sugar and similar to a sabayon, was poured over strawberries or nut tortes in Jewish and non-Jewish homes of the period.

More than the other two dishes on the page, the poached and pickled blue trout defines Mrs. Hochstaedter as a housewife of means. Poorer people might have used pickled herring or even carp, but she was able to afford the more costly blue trout, available in lakes in southern Germany. It was often served with a green sauce made from parsley.

This handwritten book, written in 1891, came 20 years after Rebekka Wolf's German Jewish Cookbook, Kochbuch fur Israelitische Frauen, "Cookbook for Jewish Women," published in Berlin in 1871.

Here is a modernized version of the gugelhopf recipe:

HUNGARIAN KUGELHOPF

1 scant tablespoon (1 package) active dry yeast
2/3 cup warm milk
1 large egg
1/2 cup sugar
1/4 teaspoon salt
1/2 teaspoon vanilla extract

2 cups unbleached all-purpose flour
1/2 cup (1 stick) unsalted butter,
 at room temperature
2 teaspoons unsalted butter, melted
2 teaspoons ground cinnamon
2 tablespoons raisins
1 tablespoon warm water

1. *Dissolve the yeast in the milk.*
2. *In the bowl of an electric mixer fitted with the paddle, mix the egg, 1/4 cup of the sugar, the salt, and the vanilla. Add the yeast mixture, then gradually the flour. Beat on low speed for 3 minutes, then turn to high speed until the dough leaves the sides of the bowl.*
3. *Place the dough in a pan dusted with flour, cover with a towel, and refrigerate for at least 15 minutes. The dough will be sticky. You can leave it for several hours.*
4. *On a floured board, roll out the dough to a 12- by 8-inch rectangle.*
5. *Spead all the soft butter over half the dough, measured from the shorter side. Fold the other half of the dough over the butter, sprinkling the board and the top of the dough with flour. Pinch the sides closed. Turn the dough 90 degrees and roll out to a rectangle again; then fold in half again.*
6. *Wrap the dough in plastic wrap, refrigerate for 15 minutes, and then roll it out and fold it in half twice more. Each time, roll it out in all 4 directions to 12 by 8 inches, turning it 90 degrees.*
7. *After the second folding, to a rectangle 8 by 6 inches, brush the top of the dough lightly with the melted butter. Cover with freezer paper or plastic wrap. Refrigerate at least 6 hours or overnight.*
8. *Roll the dough out to a rectangle about 10 by 8 inches. Mix the remaining 1/4 cup sugar with the cinnamon and sprinkle on top of the dough, leaving a 1-inch border all around. Then sprinkle the raisins over the sugar. Roll the rectangle up tight, like a jelly roll, from the shorter side.*
9. *Grease well a 7-inch kugelhopf or 9- by 5-inch loaf pan.*
10. *Place one end of the roll against the other to form a circle and insert into the kugelhopf pan, seam side up. If using a loaf pan, twist the dough once, holding the ends, so it resembles a bow tie and put it in the pan.*
11. *Let the kugelhopf rise, covered with a cloth, for at least 1 hour, until the dough is about double in bulk.*
12. *Preheat the oven to 350 degrees.*
13. *Brush the top of the kugelhopf with water and bake for 45 minutes, or until the top is golden brown.*
Yield: 1 kugelhopf (D)

Joan Nathan
Cookbook Author and Culinary Historian

II, 10
Ladino Singer Sewing Machine Manual
Livro de Instruksiones por las Verdaderas Makinas de Kuzir "Singer"
Yamadas V. S. Vaibreiting Shatl [Vibrating Shuttle] Numeros 2 i 3."
[Book of Instructions for the Authentic Singer Sewing Machines, Known
as V. S. Vibrating Shuttle Numbers 2 and 3]
Published by the Singer Sewing Machine Co., New York, 1894
Collection of YIVO Institute

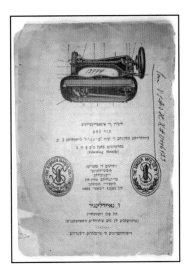

This Ladino sewing machine instruction book was probably distributed in the
Ottoman Empire.

SYNAGOGUE

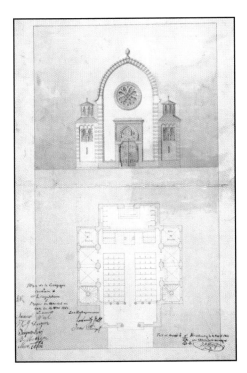

II, 11
Model of the Portuguese Synagogue
Amsterdam, 1671-1675
Architect: Elias Bouman (1636-1686)
Collection of Yeshiva University Museum

In the 17th century, Amsterdam was a haven for *conversos* fleeing the
Inquisition. They prospered in Amsterdam, due to their involvement
in trade and finance, and were thus able to build this magnificent
synagogue, with 2,000 seats and an Ark and Bimah made from rare
Brazilian jacaranda wood. The Amsterdam Portuguese Synagogue
served as the model for Sephardic synagogue buildings throughout
the world.

II, 12
Synagogue Architectural Plan
Strasbourg, 1862
Architect: J.A. Weyert
Graphite, ink and watercolor on paper
Collection of Leo Baeck Institute

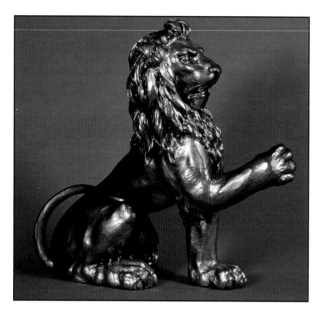

This architectural plan for a synagogue in Lingolsheim, a town just outside of Strasbourg, shows the blending of architectural traditions common to synagogue buildings throughout the world. The architect has drawn on local Alsatian vernacular traditions in brick and ironwork. He has also combined Moorish elements with Christian ecclesiastic influences - seen in the large central rose window, yet marked the building as a synagogue by the inclusion of traditional Jewish elements — such as the Decalogue above the entryway. The plan is signed by the architect, and features a list of the builders and the members of the building committee.

II, 13
Pair of Synagogue Lions, to be placed above the Torah Ark
USA, late 19th-early 20th c.,
Wood, gilt
Collection of Yeshiva University Museum. Gift of Mr. Jonas Strauchler

These majestic lions may have been carved by immigrant craftsmen from Eastern Europe, who had made carvings for synagogues and tombstones in the Old World; in America, they continued these traditions, and expanded to other folk art forms, such as cigar store Indians and carousel horses.

IDENTITIES
II, 14
Portrait of Bilhah Abigail Levy Franks (Mrs. Jacob Franks) (1696-1756)
Attributed to Gerardus Duyckinck (1695-1746)
New York City, ca. 1735
Oil on canvas
Collection of the American Jewish Historical Society. Gift of Captain N. Taylor Phillips

No colonial woman left a more engaging portrayal of contemporary family, political, and social life than Bilhah Abigail Levy Franks, as seen in both her painted portrait and in her extensive letters to her son Naphtali in England. Daughter of two of the earliest Jewish immigrants to America, and wife of one of New York's leading colonial Jewish merchants, Abigail spent her married life active in civic and religious life and focused on raising her nine children, as committed Jews and as engaged citizens of New York. But her desires to marry her children within the Jewish faith were frustrated. A daughter and a son each took Christian spouses, and many of her English and American grandchildren also converted. Of Abigail's more than two-dozen grandchildren, not one of them seems to have passed on Judaism to their descendants

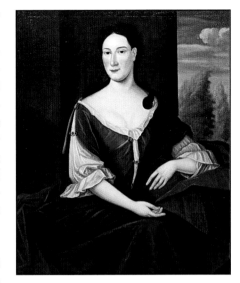

This portrait is one of a series of seven paintings of the family attributed to Dutch artist Gerardus Duyckinck. The series is the oldest known family portrait series in America; all paintings survive in their original frames. The paintings are in the style common to their era, and reflect the costumes, symbols, and landscapes of Europe. No overt "Jewish" identity is conveyed by these paintings.

It fascinates me that this portrait denies two important aspects of Mrs. Franks very essence: There is no symbol or indication of her strong Jewish identity in this English country gentlewoman-style portrait. Nor from the languid position of her hands can we divine that she was a strong, active commanding mother and community leader. Yet, the way she holds her head slightly off center, and the slight smile on her lips, indicates a distancing of self from the pose and the presentation. Ironically, it was this stance of holding herself and her family above the small Sephardic Jewish community, while remaining a passionate Jew, that led to her heartbreaking family situation. Two sons who married Jewish women lived in London — where the Jewish marriage pool was larger – and she never saw them again. At the same time she cut herself off from her daughter, who had married a Christian in New York. None of her grandchildren married Jews. The same pattern was repeated in other prominent Sephardic families of that era.

This portrait evokes a strange personal connection for me. My American Christian ancestors living in New England at that time – who would have posed for a fairly identical portrait – would never have imagined that their descendant would become a rabbi, while Mrs. Franks never imagined that none of her descendants would remain Jewish.

Rachel Cowan
Director, Jewish Life Program, Nathan Cummings Foundation

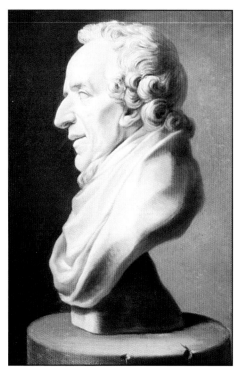

II, 15
Portrait of Moses Mendelssohn
after a bust by Jean Pierre Antoine Tassaert
Berlin, 1786
Joseph Friedrich Darbès (d'Arbès)
Oil on canvas
Collection of Leo Baeck Institute

Moses Mendelssohn (1729-1786), the son of a Dessau Torah scribe, was a renowned philosopher of the German Enlightenment and an outspoken champion of Jewish integration into general society. He maintained close friendships with important writers, including Gotthold Ephraim Lessing, who modelled his Nathan the Wise after Mendelssohn. Mendelssohn remained an observant Jew throughout his life, yet most of his descendants converted to Christianity.

Joseph Friedrich Darbès (1747-1810) served as a portraitist to the Imperial family in St. Petersburg from 1773 to 1785. In 1785, he became a master teacher at Berlin's Academy of Art. In this painting, modeled after a bust, Darbès has portrayed Mendelssohn with great reverence and formality.

II, 16
Four Family Portraits
Germany, ca. 1780-1800
Watercolor, gouache and pastel on paper
Collection of Leo Baeck Institute

Although we cannot identify the artists or sitters for these portraits, the changing modes of dress seen in the paintings indicate the massive social changes German Jewry underwent in the late 18th century. The elderly man's untrimmed beard and his wife's modest attire suggest allegiance to traditional religious practice, yet both generations of this family were sufficiently culturally integrated to commission portraits of themselves. The younger man's clean shaven face and his tricorn hat can be seen as physical embodiments of the changes German Jews encountered during the Age of Enlightenment.

II, 17
Commodore Uriah Phillips Levy (1792-1862)
Artist unknown
ca. 1816
Oil on canvas
Collection of the American Jewish Historical Society
Gift of Amelia Levy Mayhoff

In 1802, a ten-year-old boy ran away from home and, against his parents' firmest wishes, went to sea. Over the next six decades, Uriah P. Levy rose from cabin boy to Commodore of the Mediterranean fleet, the first Jew to hold such high rank in the U.S. Navy.

During his naval career, Levy captured more than twenty ships, was imprisoned in England and helped abolish flogging as naval discipline. He was also court-martialed six times, a likely result of anti-semitism and his difficult personality. Four findings were returned against him, and two others were overturned by the President of the United States. Levy lived at Thomas Jefferson's Virginia estate Monticello, purchased it in 1836, and spent great time and effort on its restoration, insuring its survival for future generations.

"He made a difference in a very difficult environment." Confronted by anti-semitism in his society and in the Navy where he served, Uriah P. Levy never gave in to the forces around him. He fought wrongdoing wherever he saw it and is credited with ending flogging in the U. S. Navy. Despite court-martials and open discrimination, he stayed on in the Navy and earned the highest rank a Jewish man had ever attained. (Commodore, the equivalent today of a Rear Admiral). He was an inspiration to Naval Officers, regardless of their religious background.

His accomplishments are particularly noteworthy considering he began his career as a young man and many of his commands were held before even reaching the age of 35. Today, although societal issues still exist, Jewish Naval Officers can now achieve ranks reflective of their skills not their religion. In the past decade we have seen Admiral Mike Boorda, become CNO, the most senior position in the Navy, and the controversial father of nuclear power, Admiral Hyman Rickover achieve 4 star rank. Without the battles fought by Uriah Levy, this acceptance of Jewish officers might have taken even longer.

–Robert A. Ravitz
Rear Admiral, US Naval Reserve, retired; President, New York Council Navy League

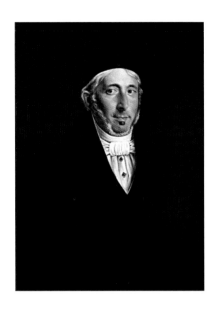

II, 18
Portraits of Cantor and Mrs. Kurtzig
ca. 1830-40
Artist unknown
Rakwitz (Rakoniewice, Poznan Province,
Eastern Germany/Western Poland), ca. 1830-40
Oil on canvas
Collection of Leo Baeck Institute

Hirsch Kurtzig (1795-1870) was a prosperous wool trader, who moved to Silesia ca. 1860. His father had been a privileged *Schutzjude*, with special protected status granted by the local ruler. Hirsch Kurtzig combined a love of music with great personal piety, and served as the Cantor in his synagogue. Little is known about his wife; she was also a Rakwitz native, and was the mother of four children. These impressive, generously scaled paintings, in a provincial Biedermeier style, were surely objects of great pride and admiration in the Kurtzig home.

By the mid-nineteenth century, it was likely that couples like the Kurtzigs would attempt to adapt to the German idea of Bildung. Loosely translated as "self-formation" or "self-cultivation," Bildung combined the concept of "education" with a belief in the primacy of culture and humanity. Bildung appealed to Jews because it could transcend differences of religion or nationality through the development of the individual. This notion was integrally connected to Jewish Emancipation: bourgeois liberals urged Jews to "improve" their character as a way of integrating into the middle class and nation. Adapting enthusiastically, Jewish men acquired solid educations and Jewish women raised refined and respectable families. Jews were, as George Mosse put it, "emancipated simultaneously into the age of Bildung and middle class respectability.

Marion A. Kaplan
Professor of History, Queens College

II, 19
Portraits of Rabbi and Mrs. Zuckermann
ca. 1840
Artist unknown
Rawitsch (Rawicz, Poznan Province, Eastern Germany/Western Poland), ca. 1840
Oil on paper
Collection of Leo Baeck Institute

The Zuckermanns most likely commissioned these oval portraits to present their artistic and cultural sophistication, and seemingly to also display their material comfort. Great attention is devoted to the depiction of expensive furs, jewelry and lace. As seen in the rabbi's long beard and in his wife's close fitting head covering, these portraits testify to the Zuckermann's maintenance of traditional observance alongside provincial sophistication and affluence.

II, 20
Selina Seixas Moses (1838-1917)
Set of eight daguerreotypes
New York, ca. 1841-1857
Collection of the American Jewish Historical Society. Gift of Blanche Moses

- age 3, ca. 1841, ninth-plate daguerreotype
- age 13, ca. 1851, sixth-plate daguerrotype
- age 16, with an unidentified baby (possibly a cousin), ca. 1854, fourth-plate daguerreotype
- age 19, probably a wedding photograph. Selina married Lionel Moses (1825-1895) on May 12, 1857. Anson Studio, New York, 1857, sixth-plate daguerreotype
- age 19, probably a wedding photograph. Anson Studio, New York, 1857, sixth-plate daguerreotype
- age 19, possibly a wedding photograph. C.D. Fredericks Studio, New York, 1857, fourth-plate daguerreotype
- age 19, probably a wedding photograph. Anson Studio, New York, 1857, sixth-plate daguerreotype
- age 19, a wedding gift to her husband. Anson Studio, New York, 1857, inscribed by Selina on the case behind the daguerreotype: "To my dear husband," sixth-plate daguerreotype

Selina Seixas, a granddaughter of the first American-born *hazan* Gershom Mendes Seixas, was born into one of America's oldest and most prominent Jewish families, and married into another. This rare series of daguerreotypes of a single individual captures Selina from her early childhood through her adolescence and marriage, across the entire era of daguerreotype photography in the United States.

Daguerreotype photography – a positive photographic image etched onto a reflective, silvered copper plate – was introduced into America about 1839 and quickly replaced painted portraits and miniatures as an affordable and accessible method of capturing human images. A daguerreotype could be made in several sizes (from full-plate through ninth-plate), and could be embellished with hand-tinting and framing. Most daguerreotypes were small and portable. After the Civil War, daguerreotypes were superseded by negative-image photography.

III. Transmission and Regeneration

MICHAEL F. STANISLAWSKI

At the heart of Judaism lies the commandment to transmit its teachings to future generations: *"ve-shinantem le-vanekha"* ("Impress these teachings upon your children") reads the fifth imperative of the *Shema Yisrael* (Hear O Israel) credo. Perhaps not coincidentally, the fifth commandment of the Decalogue is "Honor your father and your mother." Thus, a crucial symmetry is subtly evoked in the most ancient core of Jewish instruction: The duty to honor one's parents is matched by the reciprocal responsibility of parents not only to rear their children but to educate them as well in the meaning of life, of faith, of the Jewish tradition.

And so it is also entirely fitting that this commandment to teach, to transmit the Torah to future generations, is nailed to the doorposts of every Jewish home in the *mezuzah* and pressed close to both the brain and the heart of Jews who don the tefillin every morning. Through all the varieties of Judaism and Jewishness that have arisen and continued throughout the millennia of Jewish history, the imperative of transmitting Jewish knowledge and commitment to one's children has remained constant and is a commanding centrality in the lives of the Jewish people.

We are not quite sure how this was done in the most ancient periods of Jewish history, since we do not have the sources to tell us of formal schooling in pre-rabbinic antiquity. We can reasonably enough guess, however, that then, as now, and at every point in between, most of the transmission and instruction was oral, and hence, unlike objects in a museum exhibition, impervious to preservation: Mothers and fathers taught their children with words as well as gestures and most importantly, by example, what their Judaism and Jewish heritage consisted of, in prayers, rituals, mundane daily activities, and special moments of the week, the year, the life cycle.

Just as children learn how to speak by imitating their parents, so too do they learn the content of that speech and those countless nonverbal teachings that parents transmit to their children. Certainly, the Bible informs us that in the period of the return from Babylonia under Ezra and Nehemiah, the Torah was read aloud in public as part of the liturgical service, not merely as a sacral event but as a pedagogic device, to teach, to transmit, and then to interpret. Indeed, interpretation of the words of the Torah (and hence its translation into the vernacular) has always been both necessary and deemed a sacred duty, and is virtually as old as Judaism itself. Already in Second Temple times we read of the emergence and increasing importance of the scribe in Jewish society-not simply as a copyist, but as the professional preserver and transmitter of the teachings and legacy of Judaism. So it is appropriate that the oldest extant Biblical text to survive the ravages of the millennia is a fragment of the *Shema Yisrael* prayer, copied by a scribe sometime in the Second Temple period, now preserved at the Cambridge University Library.

A close second to parental instruction and reading of the Torah in public is, of course, the role of the teacher, and from

rabbinic times onward we know that the teacher was a fundamental figure of Jewish life, even in periods for which we have no records of formal schools (though they must have existed as well). Since "Torah" itself means "teaching," the most common word for a teacher – *moreh* or *morah* – are but embodiments of the Torah itself, and in due course the Hebrew word rav came to mean both "rabbi" and "teacher." The oldest document of rabbinic Judaism, the Mishnah, edited circa 200 C.E., contains hordes of valuable teachings about teaching, not least of which is the famous line in Tractate *Avot*, commonly called the "Ethics of the Fathers" in English: "Provide yourself with a teacher, acquire for yourself a friend, and judge every person favorably." Indeed, the Talmud, the central text of traditional Jewish education, beyond the Bible, is not only or even essentially a compendium of laws and dicta by the great sages of Israel but a record of the debates and disputes arising from these teachings in the academies both in the Land of Israel and in the Diaspora. From late antiquity on, schools have served as essential institutions in every Jewish community in the world, and the ideal of universal literacy was enunciated and striven toward.

The Babylonian Talmud is, of course, written in Aramaic, and to understand the history of Jewish transmission one must comprehend the multilingual nature of that enterprise. Certainly Hebrew was always and remains the core Jewish language, taught and learned throughout the millennia. It is a common misperception that after the destruction of the Temple, Hebrew was used only for holy tasks: prayer, Torah, and high intellectual disputes. In truth, Jews throughout the centuries often kept their business records in Hebrew, many corresponded in that tongue with others about their day-to-day affairs, and great literature dealing with what we now call secular subjects were penned in the Hebrew language as well. At the same time, the geographic dispersion of the Jews and their economic and social lives depended on speaking other languages as well, and thus from antiquity to the present Jews have always spoken other languages, first Aramaic and Greek and then the countless languages of the countries in which they lived. Among themselves, they commonly wrote most of these languages in Hebrew script and spoke what scholars call "hyphenated" languages; that is, versions of the local language with Hebrew and Aramaic terms added to convey especially sacred, but also increasingly secular, concerns. Thus, there developed Judeo-Arabic, Judeo-Italian, Judeo-Persian, Judeo-Provençal, and the like, used not only in daily speech but also in intellectual discourse.

Most famously and symbolically, the single most important Jewish philosophical text, Maimonides' *Guide to the Perplexed*, was written in Judeo-Arabic. Moreover, in the two most populous diaspora communities, those in Eastern Europe and the Ottoman Empire, Jews preserved and then indigenously developed the two most important diaspora Jewish languages, Yiddish and Ladino, both written in Hebrew script but based on the languages of these communities' places of origins, the German lands and the Iberian peninsula. Thus, at the beginning of the modern period, the vast majority of Jews in the world spoke Yiddish and a sizable number spoke Ladino, whereas dwindling numbers retained other Judeo- languages. In Yiddish and in Ladino there were created works of enduring literary, spiritual, and historical value, a phenomenon that continued into the modern period. In due course most Jews learned to speak, write, and think in the languages of the countries in which they lived, all the while preserving their attachment to Hebrew; in this way, German, Russian, French, Italian, Persian, Arabic, Polish, Romanian, Hungarian, and many other

languages became vehicles of Jewish learning and cultural efflorescence alongside Yiddish and Ladino. In the twentieth century, English has risen to become a major conduit of Jewish cultural creativity, at the same time as one of the miracles of worldwide linguistic history has occurred: the revival of Hebrew as a spoken language, especially in the Land, and then the State, of Israel.

Although the Jews are famous as people of the book, and are renowned as verbal people as well, words alone do not make up a culture, and wherever they have lived, from ancient Palestine to medieval Spain, to early modern Poland, to nineteenth-century Germany, to present-day Australia, Jews have created and transmitted material culture as well: ritual objects, articles of clothing, aesthetic representations, and the like. This exhibition attempts to document this nonverbal history as central to the experience of Jews throughout their history.

Finally, in the modern period the teachings and legacy of Jewishness have been transmitted through media the ancient scribes and rabbis could not even have imagined: summer camps, movies, television, radio, the computer, the Internet. Thus, even as the vehicles of that transmission are constantly changing and evolving, the ancient imperative *"ve-shinantem le-vanekha"* still stands at the very core of the Jewish experience.

MICHAEL STANISLAWSKI IS THE NATHAN J. MILLER PROFESSOR OF HISTORY, COLUMBIA UNIVERSITY

III. Transmission and Regeneration

TORAH

III, 1

The Prague Bible - Volume III: The Writings

Prague, 1489
Scribe: Mattiyah ben Jonah of Luna
Ink, gouache and gold leaf on uterine vellum
Mendel Gottesman Rare Book and Manuscript Collection, Yeshiva University
— see cat. no. I,1; see also cat. nos. II,6 and II,15.

III, 2

The Baal Shem Tov Torah Scroll

Podolia (Ukraine), ca. mid-18th century
Ink on parchment
Collection of Yeshiva University Museum

This Torah scroll belonged to Rabbi Israel Ben Eliezer Baal Shem Tov (ca.1700-1760; acronym Besht), known as the founder of Hasidsim. It was written by his personal scribe. Several words are written in a different, unprofessional hand, and may have been written by the Besht himself. These include the first and last word of the scroll (the last word of the Pentateuch is "Israel," the Besht's first name) and a portion of Genesis 21:1 mentioning Sarah, the name of the Besht's mother. This scroll is known to have formerly been in the Great *Bet Midrash* of Slavita, Vlhynia and to have been in the possession of the Jewish Community of Zdolbunow, Volynia. It is highly similar to a second Torah scroll believed to have been owned and used by the Besht.

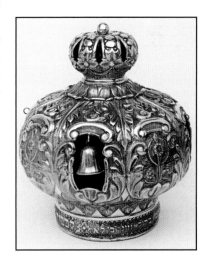

III, 3

Torah Crown

Austro-Hungary?, early 20th century
Silver: repoussé, chased and engraved
Collection of Yeshiva University Museum
Gift of The Jewish Cultural
Reconstruction

According to a Hebrew dedicatory inscription engraved on this crown, it was donated by Mordechai and Beila Brick on "the day of the giving of the Torah [5]697" (Shavuot 1937). The crown was probably crafted a few decades before it was presented to the synagogue. The Jewish Cultural Reconstruction was organized under the leadership of major scholars, such as Salo Baron and Hannah Arendt, to identify, return or find suitable new homes for Jewish cultural and religious artifacts which had been looted by Nazis, or whose original owners could not be located or identified after the Holocaust.

III, 4
Chaplain's Portable Torah Ark
ca. 1943
Used by Rabbi Joseph S. Shubow (1899-1969)
Wood and paint
Collection of the American Jewish Historical Society

Born in Olita, Lithuania, Joseph Shubow immigrated to America with his family in 1907, eventually settling in Boston. Shubow returned to Europe as a Jewish Army Chaplain from 1943 to 1946. He traveled with soldiers in France and Germany, and spent a dramatic post-war year serving Holocaust survivors in Displaced Persons camps. Writing in 1954, Rabbi Shubow commented, "Someday the Rabbi will report fully the agony and the misery that he experienced as a combat Chaplain in the service of our great country and also in defense and in protection of the ragged and wretched remnants of our people whom he found in the death camps." Though he never wrote that account, the portable army Torah Ark that traveled with him during his three years in Europe was carefully brought back by him to America, and hints at the stories of the thousands of soldiers and survivors who worshipped with him at the Ark's doors.

Shubow joined Boston's Reform Congregation Bnai Moshe upon its founding in 1933, and served it for his lifetime. He was also renowned as a regional, and later national, Zionist leader, as a fierce admirer and friend of Rabbi Stephen S. Wise, and as a fine amateur historian of the Boston Jewish community.

This portable chaplain's ark moves me profoundly. I grew up with the fact of my father's service in World War II as a Jewish chaplain — his absence during those years, the psychological wounds that he carried from opening up the Nazi death camps and blessing the remains, his weekly return to uniform in his years in the Reserves. But there could be few words. Although Dad was proud of what he had done and endured, the pain of those years went too deep for him to talk about it with his daughter. The ark, big like a coffin, with its strong handles for men like my father to carry the Torah, looks heavy. (Did the constant back pain that he suffered after the war come from lifting it?) In his office, and later at home when he retired, Dad had kept a miniature ark, housing a toy Torah. It was a model, perhaps from the war, that he took to local

churches and interfaith gatherings, and our family came to conflate it with his chaplain's ark. The real chaplain's ark here tells me that, like my knowledge of the little ark, I knew only minor bits, somehow trivialized, of what he had once experienced. His memories weighed heavily.

Helen Lefkowitz Horowitz
Professor of American Studies
Smith College

LIFECYCLE

III, 5
Two Wimpels
— Torah binders crafted from the cloth used to wrap an infant at his circumcision
Collection of Yeshiva University Museum

Germany, 1643
Linen embroidered with polychrome silk floss

Washington Heights, NYC, 1946
Maker: Rev. Reuben Eschwege
Ink and gouache on cotton

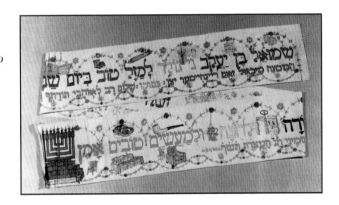

Germanic Jews probably first began to create Torah binders from infant swaddling cloths in the 16th century, and maintained this tradition for centuries in Germany and beyond. The 1643 example is one of the earliest extant, and features decorative, even fanciful, Hebrew lettering similar to that found in medieval Ashkenazic manuscripts. The 1946 Wimpel was made by and for World War II-era German émigrés living in Upper Manhattan, and features delightful 1940s decorative motifs, such as a grapefruit topped with a maraschino cherry and a sofa from the family's neighborhood furniture store.

III, 6
Seixas Family Circumcision Set and Trunk
London and New York, late 18th century
Various makers; circumcision clip by Myer Myers
Silver; wood, leather, paper and hair
Collection of the American Jewish Historical Society

Abraham Mendes Seixas (Miguel Pacheco da Silva, d. 1738) and his wife Abigail (d. 1738/9) were born in Portugal, but

settled in London and were remarried there as Jews in 1725. Their eldest son Isaac Mendes Seixas (1708/9-1780/1) emigrated to New York, and in 1740 married Rachel Levy, the daugher of Moses Raphael Levy, head of one of New York's leading Tudesco (Ashkenazic) merchant families.

In two generations, the Seixas family had traveled from Portugal to London to New York, and constructed a family and faith from elements of all three cultures. This family circumcision set was similarly constructed. The trunk, made in England, became a hold-all for small religious items. Portions of the set most likely traveled with Isaac to America, where Isaac probably commissioned the circumcision clip from New York's leading silversmith Myer Myers (1723-1795). Isaac and Rachel's son Gershom Mendes Seixas (1746-1816) became the first American-born *hazan* of Congregation Shearith Israel, New York's Spanish and Portuguese Synagogue, where Myers served as President in 1759 and 1770.

In the following generations, the Seixas family continued to marry colonial families of Sephardic and Ashkenazic descent, now living from Newport to Charleston. The circumcision set too continued to disperse and grow. It is impossible to exactly reconstruct which pieces were added when, but this set, like the family itself, displays the organic growth and dedication to their faith that the Seixas family displayed across two continents and three centuries.
— see also cat. nos. II,17 and II,20

I was told my brit milah took place in my parents' kitchen and that the mohel was not very happy because I was named after two women. The mohel was my maternal grandfather, Reverend Isadore D. Jacobs. He immigrated to this country from Budapest, Hungary trained in the Jewish ritual arts. He was a hazan (cantor), a shochet (ritual slaughterer) and a mohel (ritual circumciser). I inherited many of the ritual items that belonged to him. And I have the circumcision set that he used for me. The box is cloth-covered with a faded, purple felt lining. The shield is sterling silver. The knife is unique. It is a Miller's—the best ever made. It has a double-edged blade and a mother-of-pearl handle. They don't make them like that anymore. Now they're mass-produced, and made of stainless steel.

My grandfather passed away when I was eleven years old. I became a mohel at the age of twenty-one and from 1985 to 1990, served as one of the hazanim of Congregation Shearith Israel, the Spanish & Portuguese Synagogue, where Gershom Mendes Seixas had served as hazan, mohel and teacher two hundred years earlier. The 18th century instruments used by the Seixas family are similar in design to my grandfather's handcrafted instruments of more than a century later. Mine are modern and more utilitarian in design—not as handsome and elegant as the Seixas' or my grandfather's. Both of my sons' brisses were held in the historic main sanctuary of Shearith Israel. Since my grandfather's instruments couldn't be properly sterilized, I couldn't use them. Still, I felt deeply awed at being privileged to carry on my grandfather's legacy, bringing

my boys into the covenant of Abraham as he and Gershom Mendes Seixas and countless other mohalim before them had done for thousands of years.

<div align="right">

Philip L. Sherman
Cantor and Mohel

</div>

III, 7
Three Bridal Dresses
Collection of Yeshiva University Museum

Bindalli dress and chemise
Ottoman Empire, 19th century
Velvet embroidered with metallic threads, sequins; silk,
Gift of Mr. and Mrs. Nahman Yohai

Bindalli (lit. thousand branches – a symbol of the "Tree of Life") dresses were worn by Christian, Moslem and Jewish brides in the Ottoman Empire. This example was worn in Gallipoli (Turkey) for the ceremonial march to the mikvah (ritual bath), ca. 1910, and by two preceding generations of family members.

Wedding dress
New York City, ca. 1874-1878
Maker: Miss Tyrell
Silk taffeta changeante; glazed muslin lining
Donated in memory of Robert Hagenbacher

This fashionable, elaborately bustled taffeta dress was worn by Sarah Jacobs, a Reform Jew who immigrated to the US from Germany in the 1870s.

Keswa el kbira (grand costume),
Rabat?, 19th-20th c.
Velvet embroidered with metallic threads; silk
Sephardic Studies Collection
Gift of Mr. Abraham Pinto

This elaborate eight-piece costume is an example of the traditional festive dress of Moroccan Jewish women, worn by brides and at other celebrations. It is probably based on medieval Spanish Jewish costume, with its origins usually traced to the 15th century Spanish *vertugada* (hoop skirt, known as a "farthingale" in England).

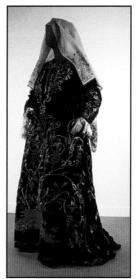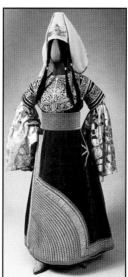

III, 8
Jar Handle with Royal Inscription
Hebron, Late Iron Age (ca. 1200-586 B.C.E.)
Ceramic
Collection of Yeshiva University Museum. Gift of Tzila and Bernard Weiss

This handle, most likely originally from a storage vessel, is marked with the ancient Hebrew inscription "Belonging to the King," indicating that it once was the property of a biblical monarch. Such inscriptions indicate that the original contents of the vessel were used to pay a royal tax, and illustrate how agricultural taxes were levied in Ancient Israel.

III, 9
Fragments of Paris un Viene
Elijah Levita (Bahur, ben Asher ha-Levi Ashkenazi, 1468/9-1549)
Verona, 1594
Collection of YIVO Institute

Elijah Levita Bahur is best known as a Hebrew philologer, grammarian and lexicographer, but he is also famed as the author of popular Yiddish tales of knightly adventure and romance, including the well known *Bove-Bukh*. Elijah was born in Neustadt, near Nuremberg, but spent most of his life in late Renaissance Italy. He lived in Padua, Venice and Rome, and taught Hebrew language and grammar, frequently to Christian Humanists.

This is a portion of one of the first works of Yiddish literature to be published. Apparently written by Elijah in 1508/9, *Paris un Viene* is the story in rhymed verse (*ottava rima* - a stanza of eight iambic lines containing three rhymes) of the love and courtship of the knight Paris and the Princess Viene. It appears to be based on a medieval Provençal romance. Only one copy of this 1594 edition survives, with other segments of the book preserved in the collection of Trinity College, Cambridge.

III, 10
Babylonian Talmud, Tractate Bava Kamma
— written by Amschel Moses Rothschild and handed down in the Rothschild family for five generations
Frankfurt, 1721/22
Ink on paper
Collection of YIVO Institute

The entire Aramaic text of this Tamudic tracate was written in small script by Amschel Moses Rothschild (d.1755, the

father of Mayer Amschel - the founder of the family's financial enterprise). The history of the manuscript's transfer within the family is recorded on the decorated frontispiece. In 1816, this Talmud manuscript was presented as a bar mitzvah gift to Anselm Salomon Rothschild, the great-grandson of Mayer Amschel.

III, 11
Judah Monis (1683-1764)
Dickdook Leshon Gnebreet: A Grammar of the Hebrew Tongue
Boston, 1735
Collection of the American Jewish Historical Society

Judah Monis' *Grammar of the Hebrew Tongue* was the first Hebrew textbook published in the American colonies, printed on the Harvard College Press with Hebrew type imported from England. Judah Monis migrated to New York City from his native Italy about 1715, joined Congregation Shearith Israel, and taught Hebrew in the community. In 1722, he became the first Instructor in Hebrew at Harvard College in Cambridge, Massachusetts, a post he held until his retirement in 1760. His conversion to Christianity on the eve of his appointment garnered worldwide attention. Critics charged it was a conversion of convenience, since only Christians could teach at Harvard, but Monis maintained until his death that he converted from conviction. The Grammar itself ends with "The Lord's Prayer" and "The Creed" in Hebrew, likely part of Monis' long-term publishing goals (most of them never realized) to try to convert the Jewish people to Christianity. A required text from 1722 through 1760, the years Monis taught Hebrew at Harvard College, the *Grammar's* printing saved students from copying the manuscript by hand, a task that could take upwards of four weeks.

III, 12
Hurban Titanic / The Titanic's Disaster
Yiddish Sheet Music, copyright 1912
Lyrics: Solomon Small (Smulewitz)
Collection of YIVO Institute

The cover of this popular sheet music features a depiction of the sinking ocean liner and portraits of Ida and Isador Strauss, owner of Macy's department store. As women and children were loaded on lifeboats aboard the sinking ship, Ida refused to be separated from her husband, and they both perished. This song was published in July 1912, just three months after the sinking of the Titanic.

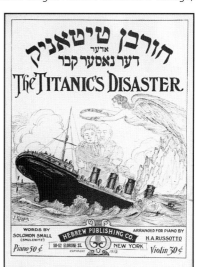

III, 13
Beit Din Record Book
Salonika (Thessaloniki), Greece, ca. 1919-1931
Collection of YIVO Institute

The Rabbinic Court of Salonika recorded their proceedings in Hebrew and Ladino cursive handwriting within commercial account books, such as this one.

III, 14
Oy Iz Dos A Maydel / Ay Que Muchacha! [Oh, What a Girl!]
Teatro Excelsior
Buenos Aires, Argentina, 1932
Color lithograph, printed by Sisto y Lemme, Buenos Aires
Collection of the American Jewish Historical Society. The Abram & Frances Pascher Kanof Collection of Yiddish Theatre and Motion Picture Posters.

By the early 20th century, America was the international center for Yiddish theater, and New York City was its capital. Virtually every American city with a Jewish community supported at least a part-time Yiddish theater, and New York City companies toured throughout the Western Hemisphere. Immigrant Jewish communities separated by distance and secular languages were united by a common Yiddish tongue, and by the Yiddish theater's tales and songs of separation, longing, farce, and achievement. Irrepressible Molly Picon (1898-1992) and her husband Jacob Kalich took their company on the road nearly every year, including several trips in the 1930s to South America. Picon specialized in sprightly, comic roles, often with a tinge of longing or sadness.

E D U C A T I O N :

III, 15
Alef-Bet Chart
Germany or Italy, ca. 18th Century
Collection of Yeshiva University Museum
The Jean Moldovan Collection. Gift of the Jesselson Family

The woodcut in the center of this chart shows students on their first day of studies being rewarded with honey dropped from heaven by an angel, while a more senior, and apparently less eager, student is flogged by a disciplinarian teacher. This chart is modeled after an example published in Ferrara in 1590, where this woodcut scene is reversed.

III, 16
Proclamation of the Vaad ha-Yeshivot
— with signatures of 85 rabbis, including Rabbi Israel Meir ha-Kohen Kagan,
the Hafetz Hayyim
Vilna, 1928
Collection of YIVO Institute

This is a handwritten proclamation of an assembly of rabbis gathered to strengthen and renew support for the Vaad ha-Yeshivot. In 1924, the Hafetz Hayyim (1838-1933) founded this organization to organize financial support for over seventy yeshivot in Eastern Poland, among them the famed institutions of Kleck, Mir, Radun and Baronowicz. After World War I, the existence of these yeshivot became jeopardized due to the poor economic conditions prevailing in Eastern Europe. The Vaad ha-Yeshivot was headquartered in Vilna from 1924 to 1939.

III, 17
Lodz Ghetto Rosh Hashanah Greeting Book
September 1941
Collection of YIVO Institute

This album contains the signatures of 14,587 schoolchildren and 715 teachers from all of the schools in the Lodz Ghetto. It was presented to Mordechai Rumkowski, Elder of the Jews in the Lodz Ghetto (the head of the Jewish "self-administration") by the Ghetto Administration's School Department on the occasion of Rosh Hashanah 5702. In this book, New Year's greetings are arranged separately by each school, accompanied by drawings and signatures. The Lodz Ghetto schools were closed in 1942, and the majority of the schoolchildren were taken to the Chelmno Death Camp in September 1942. The Lodz Ghetto was liquidated in August 1944.

III, 18
Four Toys Crafted by "Stateless Jewish Girls"
— wool teddy bear; wool dog; straw dog; straw and felt camel
Camp Trani, Italy, ca. 1946-1949
Collection of YIVO Institute

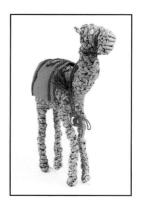

As indicated by the attached tags, these toys were made in a Displaced Persons Camp as part of a Joint Distribution Committee project by "stateless Jewish girls." At the end of 1946, there were eight Jewish Displaced Persons Camps in Italy, populated primarily by Holocaust survivors who sought to immigrate to Palestine. Zionist longing can be seen in the small toy camel made of plaited straw; its saddle blanket bears a Magen David.

III, 19
Camp Boiberik Golden Book, Volume I
Rhinebeck, New York, 1924-1958
Ink and gouache on paper
Collection of YIVO Institute

The Sholem Aleichem Folk Institute ran Camp Boiberik, a Yiddish speaking summer camp in upstate New York, from ca. 1919 to 1979. This book, which includes artwork by Tsirl Waletzky, records the historical theme of the mid-season pageant and honors the good deeds of groups and individual campers.

Camp Boiberik was the place where I grew up. My whole family were Boiberikaner – grandparents, parents, sister, brother, cousins, and in the last of my 22 summers there (1975), my wife. The many people I came to know and love among summer trees remain always intensely alive in my memory. Boiberik was a community of quickly rooted traditions, based on secular Yiddish rituals – from weekly Shabbes observances to a season-ending Felker-Yomtev (peace festival) where costumed seven-to-fourteen-year-olds represented the world's peoples. It became my privilege to add to these traditions, working on pageants and shows with wonderful pals and colleagues.

In this framework we lived the vivid joys and pains of childhood and adolescence. As youngsters, we knew we were special. We were bearers of a precious tradition connected to a rich Eastern European life of monumental triumphs and tragedies. In turn, we cared for the younger ones - did battle with the obnoxious growing pains and enjoyed the soul-healing gestures of the gute neshomes ("good souls").

The "Golden Book" captures Boiberik's special quality: the particular way it combined the ethical and the ethnic imperatives of a self-conscious Jewish community. Historical themes of mid-season pageants alternate with appreciations of the gute tatn ("good deeds") of groups and individual campers. For many years, it was my mother, Tsirl Waletzky, who created the artwork for its pages; and I remember the excitement of seeing each new summer's images emerge in brilliant colors.

The wisdom of conferring public "character awards" began to seem, by the1960s and '70s, old-fashioned, if not ill-advised. As a camper-honoree I remember both the rush of good feelings and the aftertaste of uneasiness. But the Golden Book remains – an extraordinary, loving document of an extraordinary, loving community.

Josh Waletzky
former camper and staff member, Camp Boiberik